1 . 50

THE
MAGNIFICENT
SEVEN

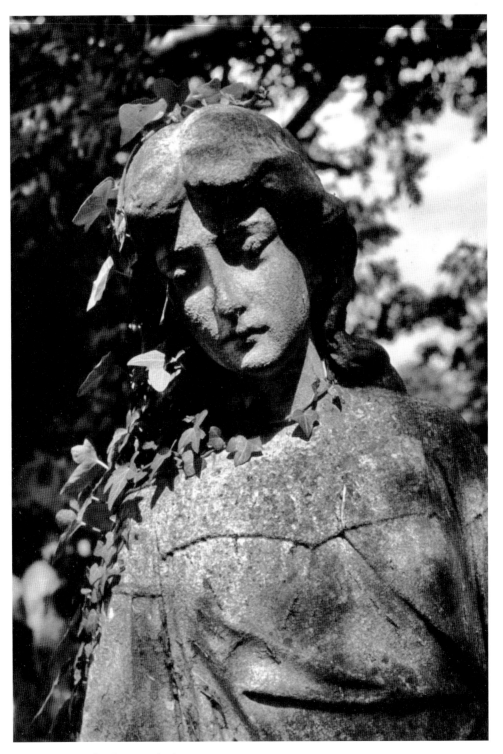

Ivy begins to garland an angelic figure.

THE
MAGNIFICENT
SEVEN

LONDON'S FIRST LANDSCAPED CEMETERIES

JOHN TURPIN & DERRICK KNIGHT

AMBERLEY

First published 2011

Amberley Publishing
Cirencester Road, Chalford,
Stroud, Gloucestershire, GL6 8PE

www.amberley-books.com

British Library Cataloguing in Publication Data.
A catalogue record for this book is available from the British Library.

ISBN 978-1-4456-0038-3

Typeset in 10pt on 12pt Sabon.
Typesetting and Origination by Amberley Publishing.
Printed in the UK.

CONTENTS

ACKNOWLEDGEMENTS

The material gathered in this book results from years of familiarity with the Seven original orbital cemeteries, together with information found in the guides published by the various Friends groups or site owners. We are most grateful for their cooperation. More extensive gazetteer and historical information is available, particularly in the standard work covering all London's numerous cemeteries by Meller and Parsons (see Further Reading).

Friends groups, run by volunteers, have a heavy burden as they engage in management, conservation and publicity, and not all of their publications may be in print currently.

It is vital that these beautiful sites are conserved for future generations, and we trust this descriptive and pictorial record will serve as an historical marker to this end.

We wish to thank Elizabeth Keenan for her technical assistance with photographs.

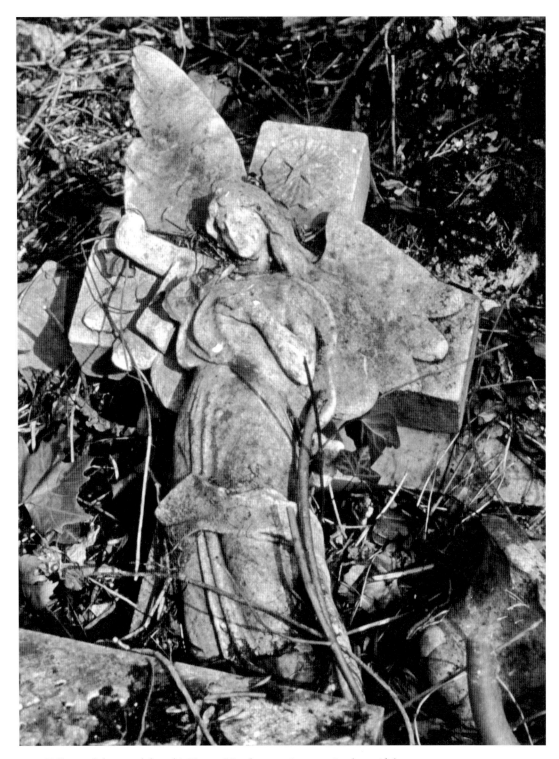

Fallen and damaged, but this Tower Hamlets carving remains beautiful.

INTRODUCTION

A ring of spectacular cemeteries, developed at the edges of London in the ten years from 1832, has long been referred to as The Magnificent Seven – and justifiably so. Together they tell a story of Victorian enterprise and progress that can impress today, and demonstrate the decent disposal of the dead.

While the great metropolis has spread around, and well beyond these Victorian gems, all survive more or less intact, extend to nearly 300 acres, and welcome visitors.

The eminent planners, legislators, architects and landscapers who turned these green-field sites into works of art for the living, as much as for the dead, would still recognise their grand designs in stone, pathways and plantings.

Sleeping giants could be an apt metaphor for this charmed ring. An Oscar Wilde fairytale portrays the garden of a selfish giant where winter lingers and change is suspended within the walls. Indeed, city life has intruded only lightly within these cemetery walls, though the inroads of nature cannot in reality be suspended.

To the many visitors who now enjoy birdsong, flora, fauna and fungi, as well as noble monuments and fine sentiments, these cemeteries may be even more wondrous than in the mid-nineteenth century, when spacious burials in designed landscapes came heaven-sent to relieve the squalor of churchyards in the burgeoning city.

The aims of this book are twofold; first to convey through pictures the natural and sculptural beauty of the London Seven – certainly greener and romantically decayed over the years; secondly, to gather together and describe some of the host of Victorian (and later) men and women, who left lasting or fleeting impressions in their time. We trust the gazetteer information will be helpful to those who have yet to seek out these capital treasures.

A PLAN SHOWING THE LOCATIONS OF
THE MAGNIFICENT SEVEN CEMETERIES

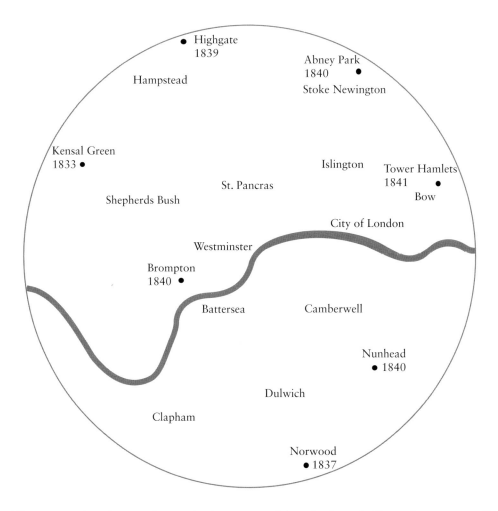

• Highgate
1839

Hampstead

Abney Park
1840 •
Stoke Newington

Kensal Green
1833 •

Islington

Tower Hamlets
1841 •

St. Pancras

Bow

Shepherds Bush

City of London

Westminster

Brompton
1840 •

Battersea

Camberwell

Nunhead
• 1840

Dulwich

Clapham

Norwood
• 1837

The cemetery locations can be seen in the context of the suburbs and villages that are now all part of inner London. There was no master plan for the distribution of the locations. After the establishment of Kensal Green, successive companies settled for the sites that best suited their interests – not too close to a competitor.

In the case of Abney Park, strong Non-conformist connections led to its location at Stoke Newington. Highgate and Nunhead cemeteries were set up by the same company in successive years on dramatic hillsides to the north and south of the capital.

HISTORICAL QUOTATIONS

• 'He was put there', says Jo, holding onto the bars and looking in.
 'Where, O, what a scene of horror!'
 'There', says Jo pointing, 'over yinder, among them piles of bones, and close to that kitchen winder! They put him werry nigh the top. They was obliged to stamp upon it to git it in. I could unkiver it for you wiv my broom if the gate was open. That's why they locks it, I s'pose', giving it a shake. 'It's always locked. Look at the rat!' cries Jo, excited. 'Hi, look! There he goes! Ho! Into the ground!'
 'Is this place of abomination consecrated ground?'

In Charles Dickens's *Bleak House* (1853), Lady Deadlock seeks the grave of her lost, destitute lover.

• 'Of the common folk that is merely bundled up in turf and brambles, the less said the better. A poor lot, soon forgot.'

Stony Durdles, funerary stonemason, in Charles Dickens's *The Mystery of Edwin Drood.*

• '…allow me to suggest that there should be several burial grounds, all, as far as practicable, equi-distant from each other, and what may be considered the centre of the metropolis; that they be regularly laid out and planted with every sort of hardy trees and shrubs; and that in interring the ground be used on a plan similar to that adopted in the burial ground of Munich, and not left to chance like Père la Chaise…'

John Claudius Loudon, from a letter to the *Morning Advertiser*, 1830.

• (A properly managed cemetery could become) … a school of instruction in architecture, botany, and the important points of general gardening: neatness, order and high keeping.
J. C. Loudon, *On the Laying Out, Planting and Managing of Cemeterie … 1843.*

HOW IT ALL BEGAN...

London's Magnificent Seven cemeteries arose out of crisis. The city in the early nineteenth century was growing exponentially as its appetite for labour sucked in country folk and immigrants who crowded together in conditions that readily became insanitary. A population of around 960,000, in 1801, rose to nearly 2 million by 1841 – with corresponding mortality.

Parish churchyards and crypts, already filled by epidemics and early mortality, were expected to cope with increasing demand for burials. The church authorities, reluctant to restrict their flow of income from funeral rites, were turning increasingly blind eyes to the squalor on their doorsteps. By the 1830s influential voices were discussing solutions, but it was not until 1852 that legislation ended burials in London churchyards.

Historically, London had been no stranger to cemeteries. As Catherine Arnold recalls in her sweeping survey, *Necropolis, London and its Dead*, 2006, the word cemetery derives from the Greek *koimeterion,* or 'dormitory', and such burial places from before and since the Roman occupation have been discovered around the old city, several associated with plague years.

Sir Christopher Wren, master-architect of post-Great Fire London, was against continuing interment within and without city churches, largely on grounds of likely structural subsidence. Had he prevailed, then suburban cemeteries would have appeared two centuries before they did.

In 1665, the Mayor and Corporation enclosed church land to the north-east of the city as a possible burial ground for plague victims. It was not used for this purpose, but was leased out as a private burial ground for Dissenters. So began the long usage of the land, known as Bunhill Fields, for Non-conformist burials into the nineteenth century, providing a direct link to one of the Seven – Abney Park. Today, Bunhill Fields is well maintained by the Corporation of the City of London.

It was the French government, however, that legitimised the cemetery by banning burials in Paris churchyards from 1804 when Père Lachaise cemetery was developed

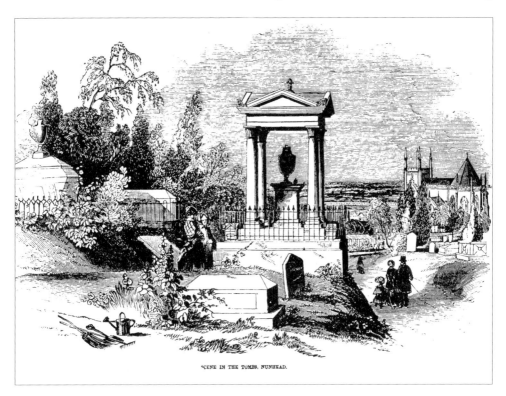

SCENE IN THE TOMBS, NUNHEAD.

An early engraving of Nunhead cemetery, emphasising the picturesque (©FONC).

on the orders of Napoleon. It became a model for other cities. British cities with significant Non-conformist populations, dissenting from the established Church and its burial rules, were also establishing independent cemeteries in the late eighteenth century – Edinburgh and Belfast being examples. The first public cemetery in England was in Norwich – called The Rosary – which opened in 1819.

Growing anxiety about disease epidemics in the crowded city was a motivating factor in the cemetery movement. Putrid air (associated with corpses) was thought to be the carrier of disease, so the disposal of bodies beyond the city, in clean air, was to be welcomed. A form of *cordon sanitaire* was to be established.

A parallel motivation was business. In an era of entrepreneurship, the profits from burials carried out with care in locations of quality could not be ignored and, once permitted, joint-stock companies flourished.

In 1830 a group led by barrister George Carden formed the General Cemetery Company, and in 1832 – coinciding with a cholera outbreak in London – an Act of Parliament permitted the company to establish a cemetery on land beside the Grand Union Canal, west of London at Kensal Green.

Support for cemeteries came from influential persons, including the writer Charles Dickens. Another was the eminent landscape architect John Claudius Loudon, who wished to improve on the rather bleak layout of the pioneering Paris

The willow bough and the widow – both weeping.

venture (see page 146). He successfully lobbied for cemetery design to be rich in natural, as well as monumental beauty – an uplifting experience for the visitor in contrast to London's accustomed squalor. And so it came about that a ring of well-spaced garden cemeteries was developed, most at a radius of five or six miles from the City.

Kensal Green was an immediate success, even attracting royal patronage, and other groups of entrepreneurs were not slow to seek land and approval for similar ventures. Funerary chapels, lodges and entrances, fine examples of neoclassical, Gothic revival or even Egyptian style, were built for both Anglicans and Dissenters. Christian dedication names – like All Souls for Kensal Green – were given to the earlier ventures when the ground was consecrated (other than areas set aside for Dissenters). Financial compensation for loss of burial fees for incumbents of London parishes was built into early legislation, as was the requirement for gratuitous burial of the destitute.

So the initiative for the seemly burial of London's dead passed to private enterprise. The high cost of plots and memorials did not deter the wealthy. But there was criticism that the bulk of Londoners were being overcharged for crowded burials in the least attractive areas.

A virtual monopoly was enjoyed by the joint-stock companies through the 1840s until the perceived need for publicly funded cemeteries was realised through the Metropolitan Interment Act of 1850. Permission was extended beyond London by a further Act of 1853.

Socially, the London Seven were a great success. The upper and middle classes saw them as appropriate showplaces to reflect their wealth and good taste when death visited the family – as it frequently did in the mid-nineteenth century. Location and landscape proved a magnet for city dwellers, as had been predicted, the cemeteries becoming destinations for respectable weekend outings. Indeed, these were one of the very few places where widows and single ladies might visit unaccompanied. There could even be matrimonial possibilities...

The cemetery entrepreneurs will be acknowledged in later pages, but in particular we must honour two of these eminent Victorians. Carden's vision and Loudon's aesthetic led to the extraordinary green ring of the Magnificent Seven (and subsequently many fine cemeteries elsewhere) until the wheel of history brought great changes in the mid-twentieth century, resulting in the failure of most management companies, but with new leases of life to follow in the public sphere or under enlightened ownership.

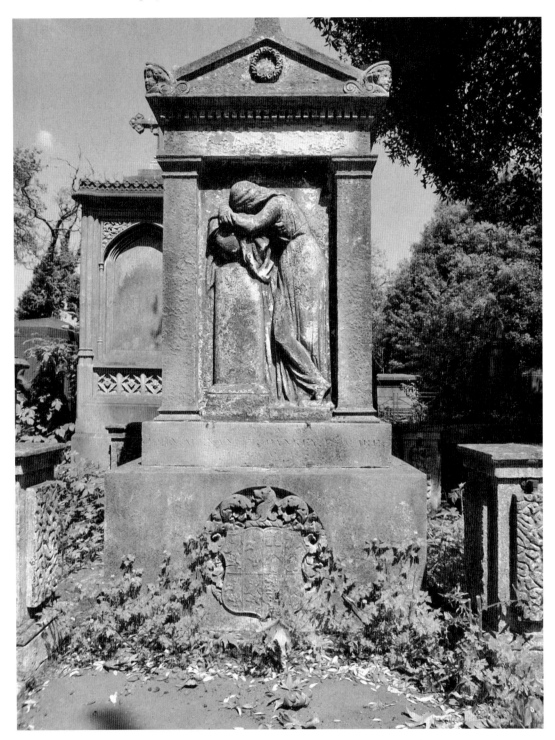

Classical references were favoured at the first of the Seven cemeteries, Kensal Green, opened in 1833.

Christian symbols gained prominence towards the end of the nineteenth century; this Orthodox example is at Norwood.

KENSAL GREEN CEMETERY

Location: Harrow Road, London, W10 4RA

Opened: 1833 by The General Cemetery Company

Extent: 72 acres

Owners: The General Cemetery Company

Access: daily free access

Friends Group: Friends of Kensal Green Cemetery. www.kensalgreen.co.uk

Tours each Sunday, March to October, otherwise 1st and 3rd Sundays, catacombs included on the 1st and 3rd Sundays

The neoclassical chapels, lodges and arched entrance were by John Griffith; landscape by Griffith and Richard Forrest. A power struggle and disagreement about whether to build in Gothic or Classical styles caused George Carden, acknowledged 'father' of the cemetery movement, who was a Gothic enthusiast, to be voted off the original board.

The cemetery is English Heritage Grade I, and over 100 monuments are Grade II or higher.

This is a working cemetery, uniquely among the Seven in business under its original name.

A Snapshot

The first of the great London cemeteries to be established, Kensal Green is distinguished by its integrity (spared the most severe neglect and vandalism experienced elsewhere), and by its wealth of sculpted monuments and free-standing mausolea. It has been immortalised by the poet G. K. Chesterton in the couplet:

For there is good news yet to hear and fine things to be seen,
Before we go to Paradise by way of Kensal Green.

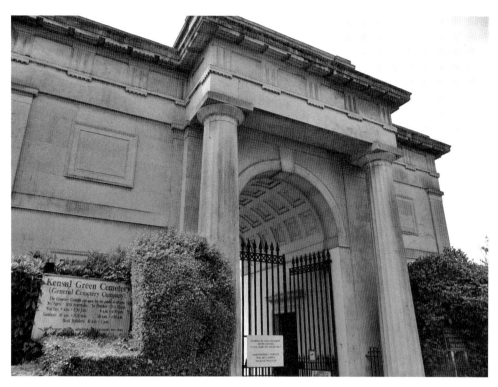

Architecture designed to impress: Kensal Green's entrance with huge columns.

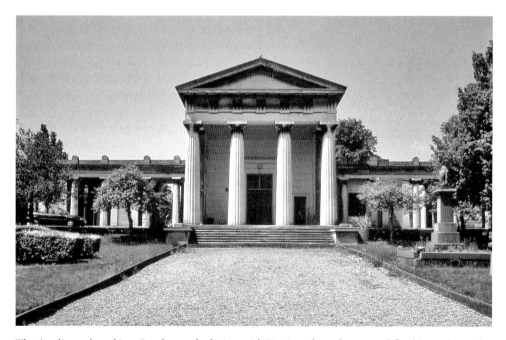

The Anglican chapel is a Greek temple design with Doric order columns and flanking colonnades above catacombs.

With its Ionic order portico, the Non-conformist chapel (restored late twentieth century) is also imposing though not raised like the Anglican chapel.

Occupying a long site, narrower at one end and largely symmetrical, the cemetery is impressively formal where the Anglican chapel, with Doric order portico and flanking colonnades over catacombs, looks out past fine spaced monuments towards a large circle with paths crossing axially. The Dissenters' chapel (Ionic order), splendidly restored in 1997 with funds that also provided for a visitors centre, is found at the east end of the site.

Towards the edges there are wooded sections and areas of meadow grass and wild flowers. The southerly boundary follows the Grand Union Canal, of which tantalising glimpses can be seen. To the west is the Crematorium with two chapels and Gardens of Remembrance. There is an area for Orthodox interments, and to the west is St Mary's RC cemetery.

Don't Miss

- Royal approval: Princess Sophia and Augustus Frederick, Duke of Sussex – daughter and son of George III – are buried here, and also three other Dukes.
- Water gates, derelict and overgrown, that would enable a canal-borne funeral.
- Extensive catacombs with restored hydraulic mechanism for lowering coffins from the chapel floor.
- An interesting area of more recent burials reflecting the changing ethno-cultural nature of the area (reclaimed from banked-up marginal land).
- The Ducrow memorial: an extraordinary assemblage, in gentle decay.

The extensive colonnades cover catacombs, and also house early memorials.

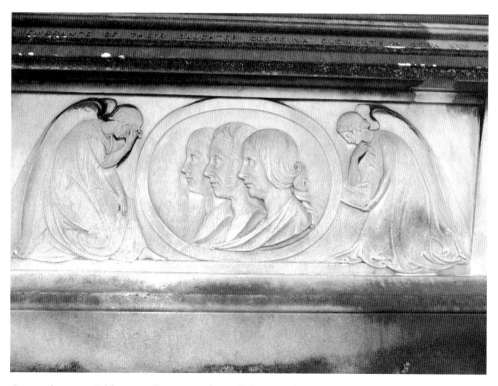

One such memorial has a well-preserved panel showing deceased family members.

Hall of Fame

Sir Marc Isambard Brunel (*d.* 1849)
Arrived in England via New York having fled the French Revolution. He was a civil engineer who constructed the first Thames tunnel at Rotherhithe – a long and hazardous operation. Also buried here, **Isambard Kingdom Brunel** (*d.* 1859) (son of Sir Marc). A giant of the steam age, designing great iron ships, building the Great Western railway and others, and suspension bridges over the rivers Tamar and Avon. His statue at Paddington station, not far from Kensal Green, marks another of his surviving triumphs.

John Claudius Loudon (*d.* 1843)
An influential landscape gardener and horticultural writer, who visualised the great landscaped cemeteries and promoted public parks. An acknowledged workaholic, he died standing up. His wife **Jane Loudon** (same grave) wrote a futuristic novel, *The Mummy!*, before their marriage, and was the author of best-selling gardening books and magazines for ladies.

Anthony Trollope (*d.* 1882)
Worked for the Post Office and introduced the pillar box; he wrote forty-seven novels, notably the 'Barsetshire' series. **Wilkie Collins** (*d.* 1889) was a pioneer of English detective fiction, who wrote *The Woman in White* and *The Moonstone*.

Jean-François Blondin (*d.* 1897)
He was a tightrope walker who crossed the Niagara Falls in 1859, repeating the feat blindfold, then with a man on his back, then on stilts, finally pausing halfway to make and eat an omelette.

Sir William Siemens (*d.* 1883)
Inventor and entrepreneur, who ran the London branch of the engineering business set up with three of his brothers, concerned with telegraphs, electric lighting, tramways and furnaces for steel and glass making. He was a Fellow of the Royal Society.

James Barry (*d.* 1865)
A woman doctor who rose to Inspector General of the Army Medical Department; she kept her female identity secret until her death. Her headstone does not mention her gender.

Charles Babbage (*d.* 1871)
An outstanding mathematician and the father of modern computing; the government granted him £17,000 to develop a calculating machine.

William Powell Frith (*d.* 1909)
A hugely popular painter of Victorian crowd scenes, such as *The Railway Station* (Paddington) and *Derby Day*; his remains were deposited in catacomb B.

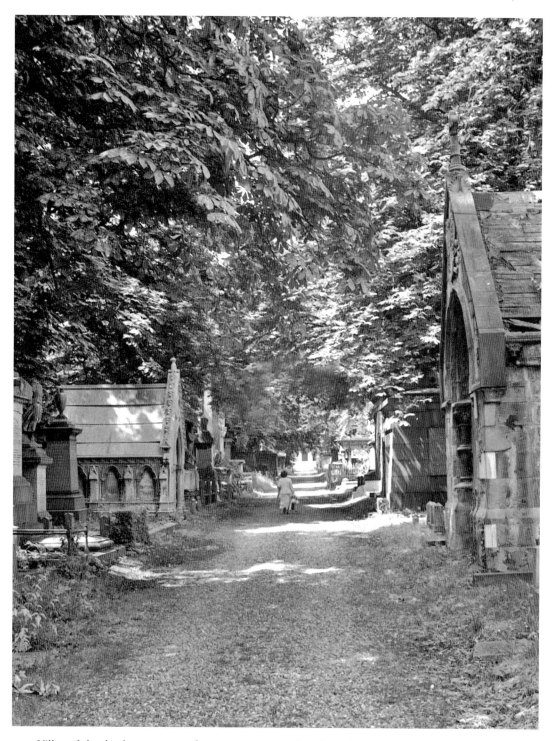

Villas of the dead: an avenue of mature trees now dwarfs early mausolea – a scene resembling Père Lachaise cemetery, a prototype for Kensal Green.

George Augustus Polgreen Bridgetower (*d.* 1860)
Iconic violinist of African-Polish decent who led the Prince of Wales' private orchestra, gained the respect of Beethoven, and was awarded a Bachelor of Music degree.

Lady Ann Isabella Noel Byron (*d.* 1860)
Briefly the wife of Lord Byron. She devoted the rest of her life to social reform, founding an industrial and agricultural school to the west of London. Their daughter Augusta became a famous mathematician and patron of Charles Babbage (see above).

Thomas De La Rue (*d.* 1866)
Printer of playing cards and ornamental paper; the business expanded to become a major printer and government contractor for banknotes and stamps.

English Royal family
See **The George III Connection** p. 28.

Andrew Ducrow's 'Egyptian' memorial to his first wife rewards close inspection for its many details, though its flamboyance was too much for some Victorians (see Palace of Varieties p. 128).

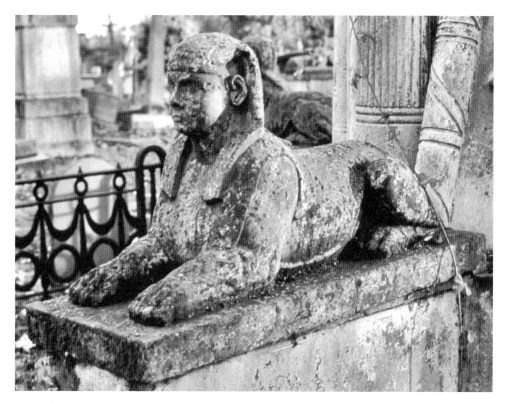

Many details are moulded in artificial stone.

Others are carved from marble like the lady's hat and gloves on a 'broken' column.

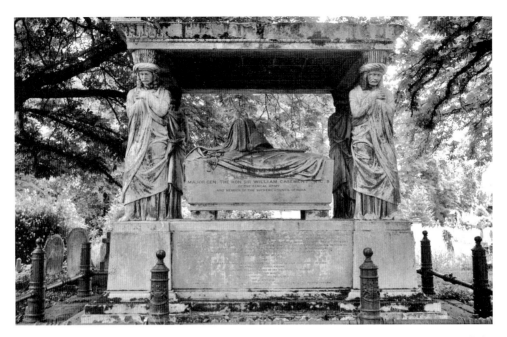

Four servants of the British Raj stand guard in effigy (composed of artificial stone) around the tomb of Gen. Sir William Casement (*d.* 1844), an Administrator of India.

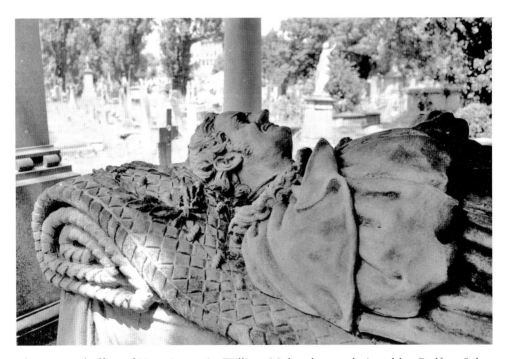

The canopied effigy of Victorian artist William Mulready was designed by Godfrey Sykes and shown at the Paris Exposition of 1867; it is also a tribute to the enduring properties of 'Pulhamite' artificial stone.

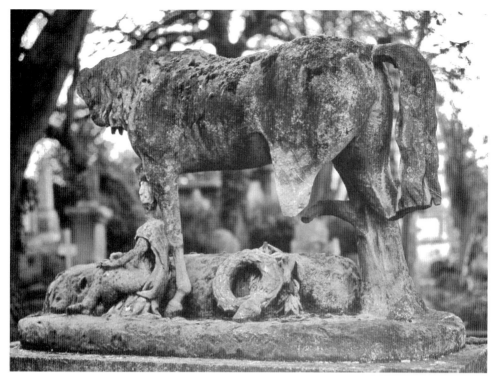

Badly damaged but evocative, this horse and child figure recall Alfred Cooke, equestrian and breeder of circus horses (*d*. 1854).

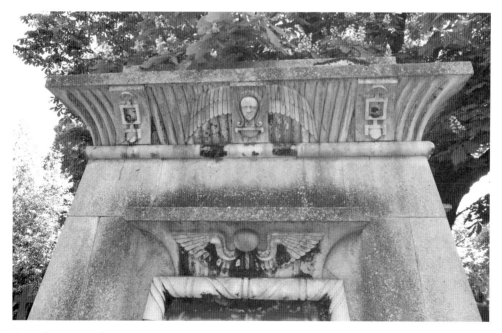

An early essay in funerary Egyptian mythology displays a 'death mask' (top centre).

The George III Connection

Windsor is the traditional last resting place for British royals. But the family of King George III was large and somewhat eccentric, which led certain Hanoverians to favour the new, fashionable and quite grand cemetery at Kensal Green.

The Duke of Sussex (1773-1843), third son of the monarch, married twice in contravention of the Royal Marriage Act, his second wife being buried with him. His home was full of singing birds and chiming clocks. Upset by confusion and delays at the funeral of William IV, he vowed not to be buried at Windsor. Over his grave is a huge slab of Aberdeen granite.

Below a beautiful Renaissance-style marble sarcophagus is buried Princess Sophia (1777-1848), one of George III's many daughters, who fell in love with a court equerry. The scandal of the birth of a son was kept from the king. In later life she became blind. Her memorial was raised by public subscription and is set in front of the Anglican chapel.

The Duke of Cambridge (1819-1904) was a grandson of George III and Commander in Chief of the Army, serving in the Crimea. His was the last great funeral at Kensal Green. A morganatic marriage to Sara Fairbrother, known as Mrs Fitzgeorge, was a well-kept secret, though she and several of their children are buried with him. An Egyptian-style mausoleum marks the grave.

For further details of aristocratic burials see *Paths of Glory*, 1997, from the Friends group.

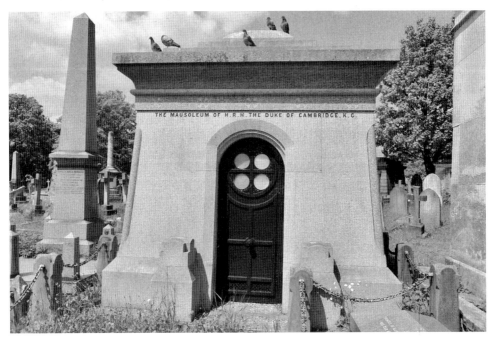

A dignified last resting place for the Duke of Cambridge, a grandson of George III; he was one of the royal interments that did so much to promote Kensal Green cemetery.

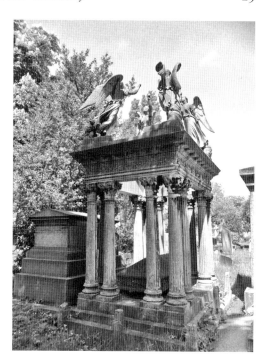

This delicate company of angels seems to be guiding the departed soul, above a fine neoclassical memorial.

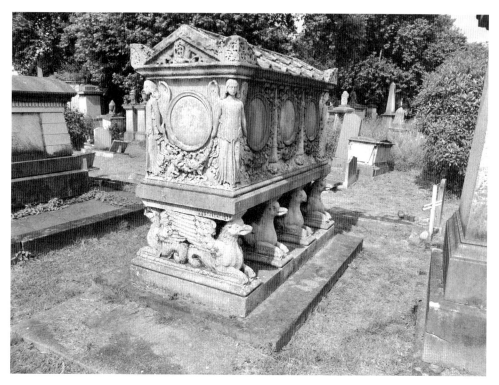

A Renaissance-style sarcophagus supported by mythical beasts was chosen for William Holland (*d.* 1856), a well-connected furniture maker and undertaker.

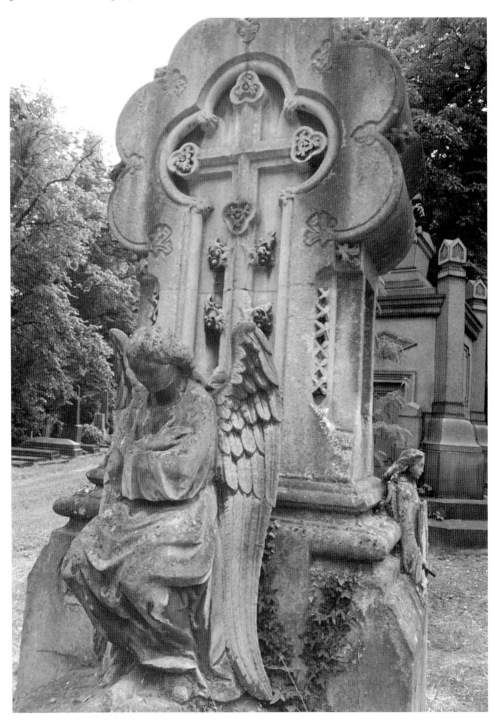

A Gothic statement; Henry Kendall was winner of the competition for the design of the cemetery buildings. Other company directors, however, favoured the neoclassical style and in a boardroom battle Kendall's plans were shelved. He was permitted to keep his 100gns prize. He designed his own memorial in the florid style he favoured.

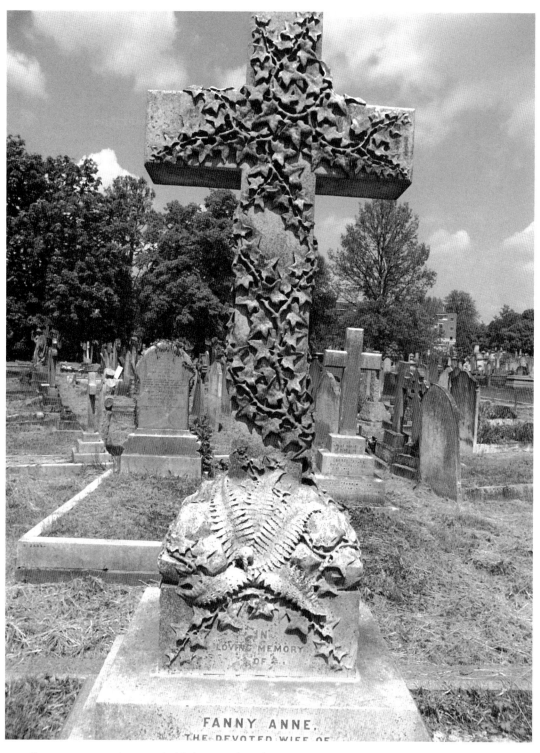

Evergreen memories; a veritable botanical garden is carved into this cross and its base.

These mausolea in polished black stone express a modern southern-European style.

Demand for new burial space at Kensal Green has been met by reclaiming marginal land.

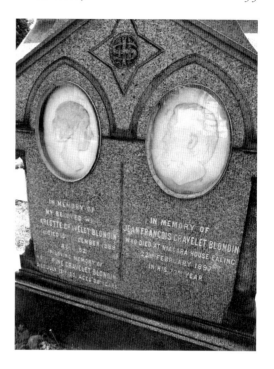

Blondin was a tightrope-walker extraordinaire, seen here in cameo with his wife. He died in 1897 at Niagara House, Ealing – the name recalling the location of his greatest feats.

A finely carved sarcophagus placed high above the burial place of Princess Sophia, a daughter of George III (see p. 28). Kensal Green's Anglican chapel is seen on the left.

NORWOOD CEMETERY

Location: Norwood Road, London, SE27 9JU
Founded: 1836 by the South Metropolitan Cemetery Company
Extent: 42 acres
Owners: London Borough of Lambeth
Access: daily free access
Friends group: Friends of West Norwood Cemetery. www.fownc.org

Entrance arch and gates, railings, lodge and catacombs survive, though two chapels were demolished post-Second World War. The style is Gothic by William Tite, who also designed the landscape.

The cemetery is listed Grade II*, and there are sixty-five monuments listed Grade II or II* – a high proportion of mausolea and monuments of the highest quality. West Norwood (as it is generally called) remains a working cemetery. It also houses a crematorium and memorial gardens.

A Snapshot

An undulating site, with attractively spaced deciduous and evergreen trees, well-managed 'meadow' areas and some dense vegetation, allows a gradual unfolding for the visitor on foot or by car – the twisting routes are mostly wide and surfaced. A large crematorium building (c. 1960) and modern chapel occupy the elevated central area. Interesting memorials are found in all parts, though a particularly rewarding spot is the lush Ship Path.

For many, Norwood's greatest treasure lies tucked into a hollow to the north-east. This is the Greek colony cemetery developed over several decades as a compact Delphic group of temple-style chapels together with mausolea and sarcophagi commemorating merchant families settled in London.

Such was the wealth of many families who chose Norwood for burials that it was known as the millionaire's cemetery.

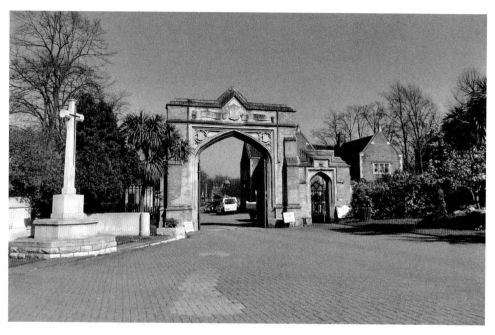

Norwood cemetery's original entrance arch, gates and railings; the fine Anglican chapel was war-damaged and demolished.

This 'modernist' mausoleum stands near the entrance. The monogram on the glass and metal door refers to Edmund Distin Maddick (*d.* 1939) who was a surgeon but also director of Kinema Operations in the First World War and builder of the Scala Theatre, London.

Don't Miss

- The Greek 'colony'.
- Terracotta mausolea by Doulton of Lambeth.
- Ship Path and Doulton Path: 'rural' routes with much interest.
- Styles of funerary portraiture: Revd Charles Spurgeon, Mrs Gallop, Baron de Reuter.
- The delicate filigree iron memorial to Mrs Ann Farrow.
- The vast and elaborate memorial to Alexander Berens, said to have cost £1,500 in 1858.

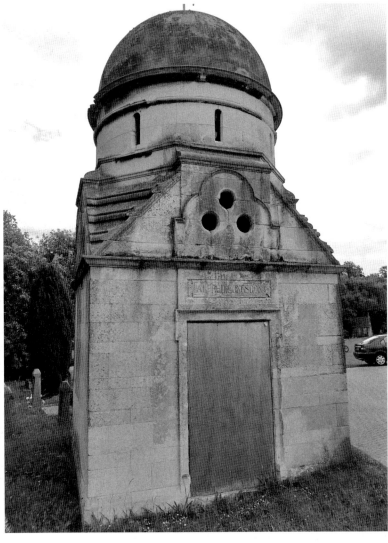

Curiously Byzantine in style is the last resting place of Alfred Longsdon.

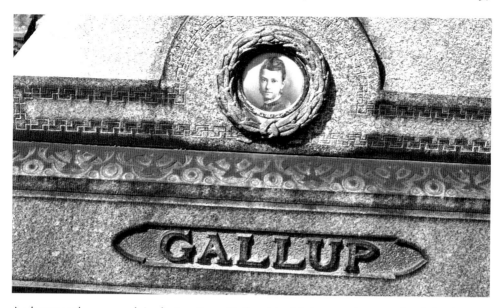

A photograph on porcelain depicts Lucy Gallup (*d.* 1883), an early example of this form of memorial picture. Her American husband was a producer of patented toiletries such as 'Fragrant Floraline' (for the mouth) and 'Mexican Hair Restorer'.

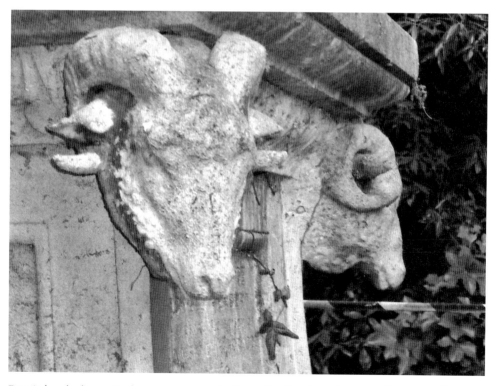

Ram's heads decorate the memorial to the Letts family of stationers, still a major brand in diaries.

Hall of Fame

Thomas Cubitt (*d.* 1855)
Regarded as the first large-scale speculative builder, he created most of London's Belgravia and Pimlico (which involved major drainage schemes), and pioneered the permanent employment of all tradesmen.

Sir Hiram Stevens Maxim (*d.* 1916)
Born in the USA, this man was an engineer and inventor. His lightweight, rapid-firing machine gun was revolutionary and highly successful.

Sir Henry Bessemer (*d.* 1898)
His inventions featured at the Great Exhibition of 1851, but he is most noted for a converter that enabled high quality steel to be made cheaply. He lived at a large estate on Denmark Hill, south London.

William Burges (*d.* 1881)
A leading architect in the Gothic style, noted for Cardiff Castle, Cork Cathedral and his own house in Kensington. His Grade II* monument is topped with a horizontal carved foliated cross of his own design.

Sir Henry Tate (*d.* 1899)
A Liverpool grocer whose business became Tate & Lyle, he founded libraries and numerous charitable institutions, also the Tate Gallery, London. His terracotta mausoleum is listed Grade II*. (Another sugar-baron, Henry Bear, is reputed to have invented the cubing machine that enabled Henry Tate to launch his innovative product, sugar cubes. Tate was known as 'Mr Cube'. Bear died in 1897 and is buried at Tower Hamlets).

A similarly listed mausoleum, also from the firm Doulton of Lambeth, was built for **Sir Henry Doulton** (*d.* 1897), second generation of the glazed stoneware pipe manufacturer, who later developed domestic items (Royal Doulton) and employed hundreds of artists.

Isabella Mary Beeton (*d.* 1865)
Mrs Beeton's Book of Household Management was the most comprehensive work of its kind ever attempted, working alongside her husband who was a writer and editor. She died aged twenty-eight during the birth of her fourth child, having lost her first two in infancy.

David Roberts (*d.* 1864)
Landscape and architectural painter, particularly watercolours of the Middle East, where he travelled extensively; elected Royal Academician in 1841.

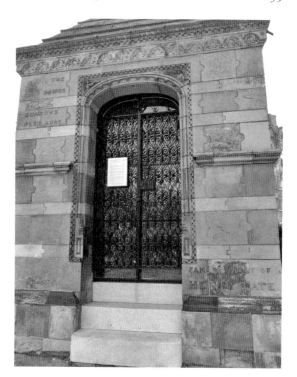

One of the fine terracotta mausolea at Norwood, this one is for Sir Henry Tate, the sugar magnate.

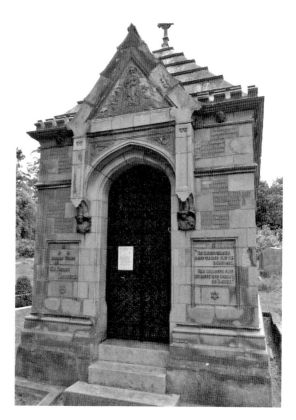

Rather more ornate is the mausoleum to Sir Henry Doulton, whose firm – Doulton of Lambeth – provided both these listed memorials.

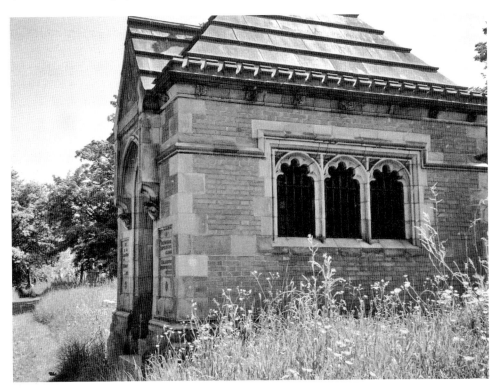

A side view of the Doulton mausoleum.

Charles Haddon Spurgeon (*d.* 1892)
Preacher who founded the Metropolitan Tabernacle, still at the hub of London's Elephant and Castle district. Congregations were huge, as were numbers of mourners at his funeral. His prominent monument bears a marble bust.

Thirty-nine people buried at Norwood have connections with **Charles Dickens**, as revealed by his letters, and other sources. This impressive piece of detective work is detailed in *The Dickens Connection* by Paul Graham (from Friends of West Norwood Cemetery).

The Greek Connection

Many Greek merchant families settled in London from the 1820s, founding a community with its own religious life. In 1842, areas of ground in the unconsecrated section of the cemetery were leased by a group from the community, and between then and 1889 three further adjoining parcels of land were similarly added.

Today the Greek section at Norwood is densely filled with some of the most dramatic funerary architecture in the metropolis, though sadly the merchant families of today seem no longer able to contribute to essential conservation.

Dominant on rising ground is a colossal mortuary chapel in classical temple form with double portico, built of Bath stone. It was erected by and for Stephen Ralli, probably in the 1870s, architect unknown. In the triangular pediment there are sculptures illustrating the quotation: *The trumpet shall sound and the dead shall be raised*, inscribed in Greek below. There is a frieze of sculpted panels with biblical scenes below the pediment.

Richly sculpted mausolea and other monuments abound, several featuring children. There are fine bronze doors on some mausolea, and much high quality carving of foliage, Christian symbols and other decoration, together with some coloured mosaic work. The chapel (restored in the 1970s) and a mausoleum to another Ralli family member are listed Grade II*, while sixteen further monuments carry a Grade II listing.

Sadly, a forest of young ash and sycamore trees has sprung up within the stonework and threatens to force many of these treasures apart.

For further details see *Norwood Cemetery: an Introductory Guide*, 2007, from the Friends group.

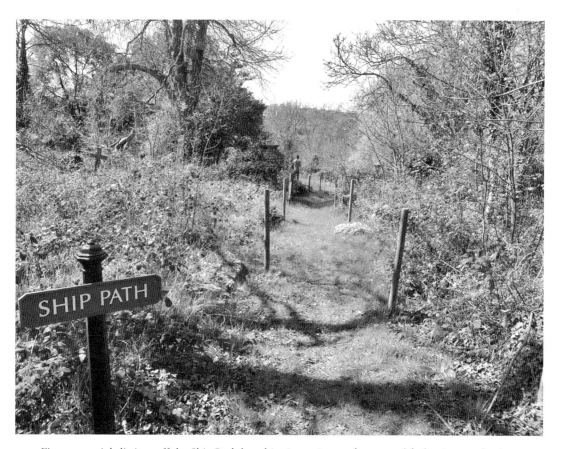

Fine memorials lie just off the Ship Path but this viewpoint confers a rural feel to inner-suburban Norwood.

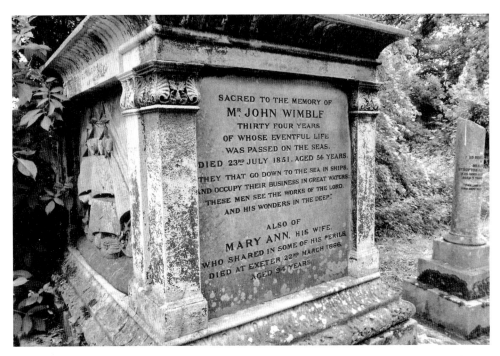

SACRED TO THE MEMORY OF
Mr JOHN WIMBLE
THIRTY FOUR YEARS
OF WHOSE EVENTFUL LIFE
WAS PASSED ON THE SEAS.
DIED 23RD JULY 1851, AGED 54 YEARS.

"THEY THAT GO DOWN TO THE SEA IN SHIPS,
AND OCCUPY THEIR BUSINESS IN GREAT WATERS:
THESE MEN SEE THE WORKS OF THE LORD,
AND HIS WONDERS IN THE DEEP."

ALSO OF
MARY ANN, HIS WIFE,
WHO SHARED IN SOME OF HIS PERILS,
DIED AT EXETER 22ND MARCH 1886,
AGED 84 YEARS.

Ship Path takes its name from the dramatic relief carvings of sailing ships on the tomb of John Wimble. Of his fifty-four years, thirty-four were spent at sea, his wife sharing some of his perils.

John Wimble's tomb.

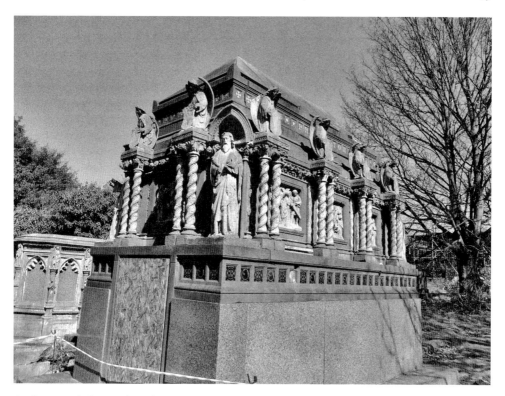

At the top of Ship Path is the awesome 'Medieval' tomb of Otto Alexander Berens, draper of St Paul's Churchyard (*d.* 1860). The work was completed two years earlier by E. M. Barry and illustrated in *The Builder* magazine. Four Evangelists and other biblical figures are by sculptor Thomas Earp, who is buried at Nunhead cemetery.

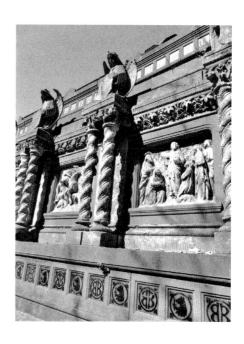

Minton tiles feature the letter B, and Berens' adopted bear motif.

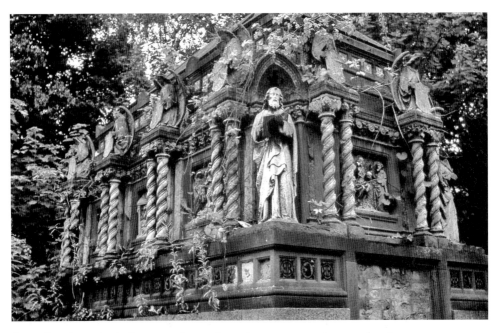

An earlier photograph shows weed growth on the structure, prior to a cleaning programme.

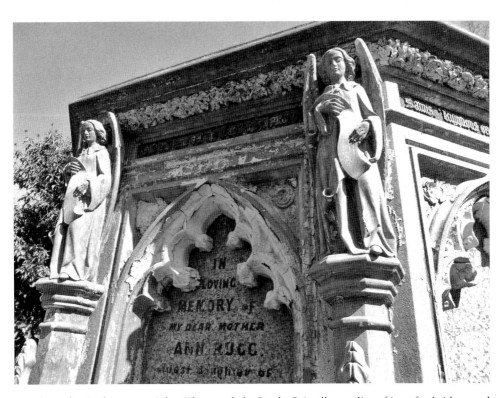

Nearby is the Gothic memorial to Thomas de la Garde Grissell, supplier of iron for bridges and major London landmarks (*d.* 1847).

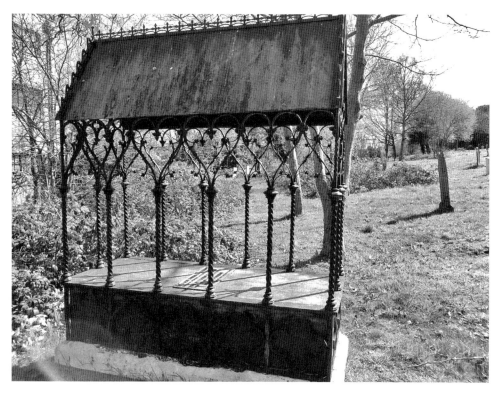

The Victorians were proud of their metal-working skills, as this Gothic-style gem in wrought and cast iron testifies. It was saved by careful restoration in 1999. Buried here is Ann Farrow (*d.* 1854) widow of a manufacturing ironmonger supplying the wine and spirit trade.

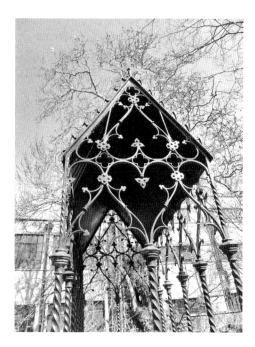

Another view of the delicate Farrow memorial.

This Garden of Remembrance is a modern development in a corner of Norwood cemetery, which also houses a crematorium.

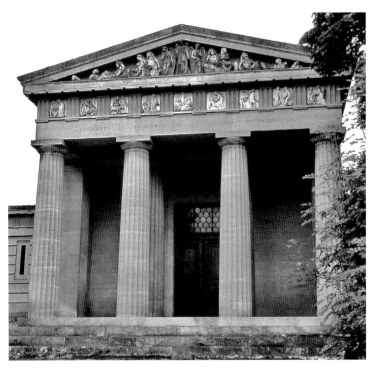

The special area for Greek community interments contains mausolea and other memorials of great quality and artistic merit, such as the mortuary chapel for Augustus Ralli who died in 1872 while at Eton College.

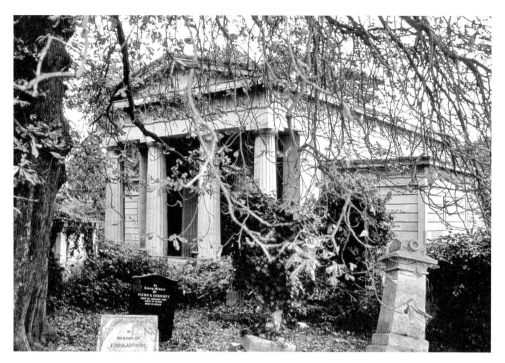

The Ralli chapel also has a Doric order rear portico.

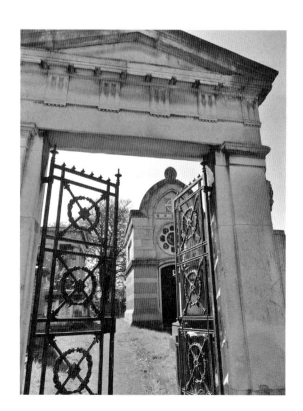

Through the entrance arch to the Greek section can be seen a robust mausoleum for another Ralli family member, the work of G. E. Street.

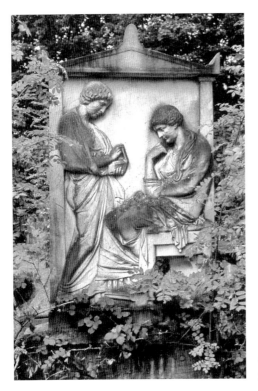

Greek antique forms can be recognised in the relief carving on this stone.

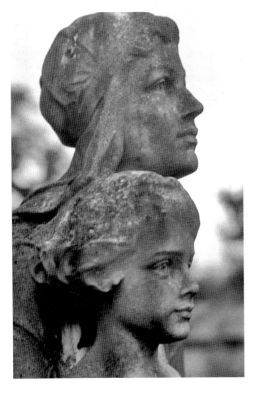

A free-standing mother and son group is distinctly modern (early twentieth century).

More than one of the Greek headstones has a ceramic mosaic design. Vault collapse is evident in the adjacent plot.

This memorial and the photographs that follow illustrate the diversity and quality of the funerary architecture to be found in the Greek section at Norwood Cemetery.

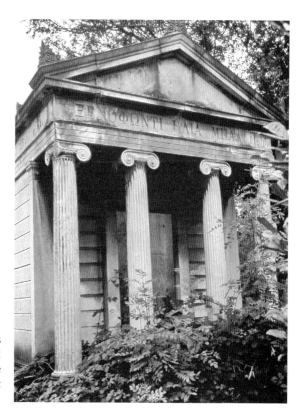

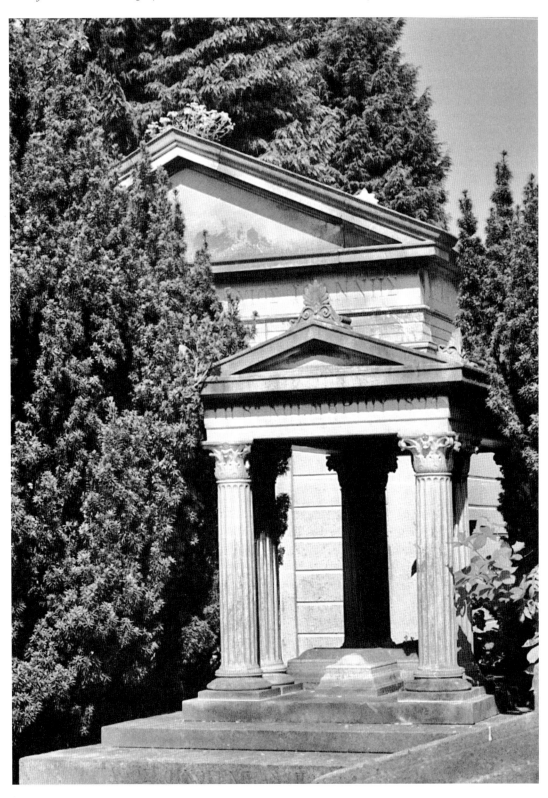

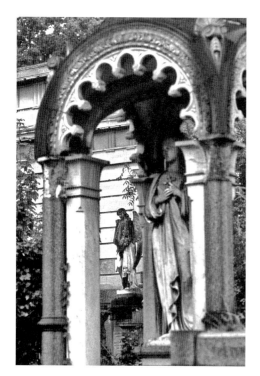

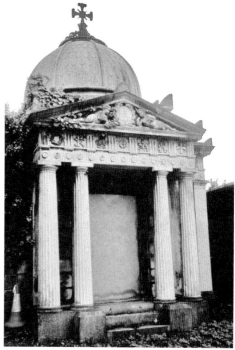

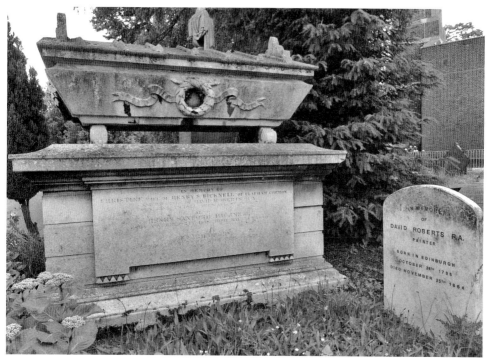

David Robert was and remains a noted landscape painter. His very modest stone is beside the grand memorial of his daughter and son-in-law, the Bicknells, whose wealth derived from whaling.

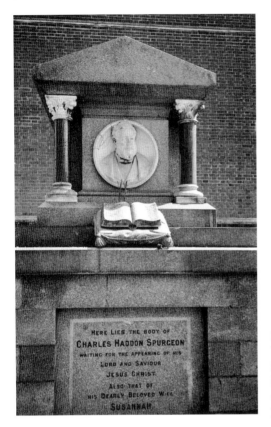

In cameo with his bible is the great Victorian preacher, the Revd Charles Spurgeon, whose south London church is still called Spurgeon's Tabernacle. He also founded children's care homes and a preachers' college.

Framed by a weeping willow, this carved lectern with bible and cushion records John Spreull who came to London from the Shetland Isles.

HIGHGATE CEMETERY

Location: Swain's Lane, London, N6 6PQ
Founded: 1839 and 1854 by the London Cemetery Company
Extent: 37 acres
Owners: The Highgate Cemetery Charity (managed by Friends of Highgate Cemetery Trust) T 020 8340 1834
www.highgate-cemetery.org
Access: Eastern cemetery open daily; Western cemetery admission by guided tour only (2pm on weekdays, more frequent at weekends)
Entrance and chapels in brick Tudor-Gothic by Stephen Geary, terrace catacombs by James Bunstone Bunning and Thomas Porter. English Heritage listed landscape: Grade I*.

A Snapshot

On its steep northern heights Highgate must rank as the queen of London's Victorian cemeteries. With a unique ownership structure, this busy working cemetery combines rigorous fund-raising with sensitive management of a fragile landscape.

Highgate's Western cemetery (opened in 1839) and the Eastern extension (of 1854) offer distinct aesthetic experiences. Entrance to the older cemetery is through a gated arch with restored Anglican and Dissenters' chapels to either side; a quiet architectural ensemble. Across a courtyard is a retaining arcade with steep steps at its centre, providing no hint of the *coup de théâtre* that will reward a steep climb.

When it emerges out of the trees, the Egyptian Avenue and associated chambers, catacombs, mausolea and columbarium is a sight worthy of the ultimate production of Verdi's *Aida*. But unlike a stage-set, this unique grouping is testament to heroic conservation efforts over several decades. Overarching these works is a mighty cedar of Lebanon, probably dating from the late seventeenth-century landscape of Ashurst manor.

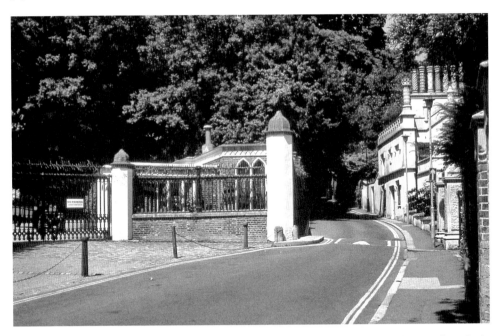

The approach to Highgate cemetery along Swain's Lane (shared with Waterlow Park) is little changed since its mid nineteenth-century foundation.

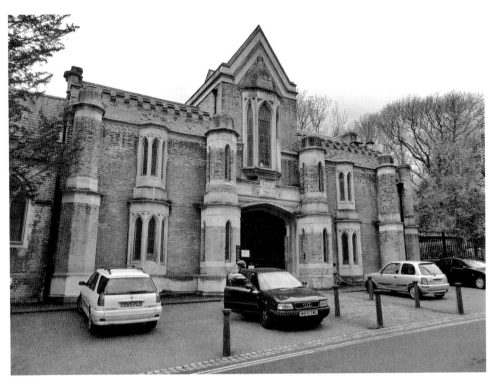

Highgate's imposing entrance in Tudor-Gothic style.

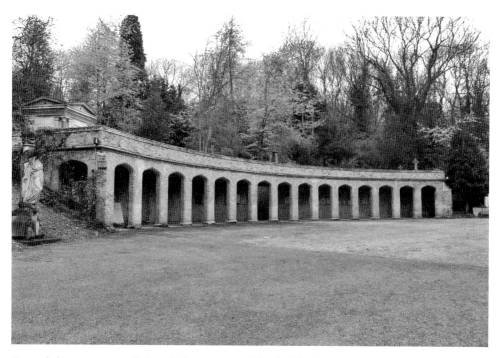

Beyond the entrance and chapels is a courtyard backed by this imposing arcade, with central steps leading mysteriously upwards.

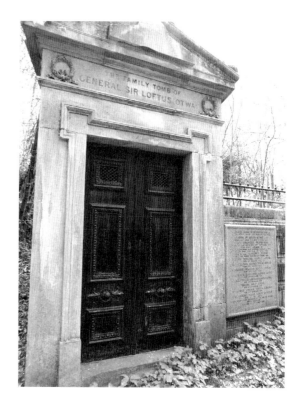

Sir Loftus Otway was one of the Duke of Wellington's generals in the Napoleonic campaign. There is an extensive vault to the right of the doors.

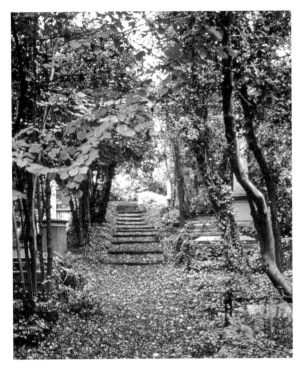

Early autumn leaves carpet the steps that lead the visitor upwards.

This fine redwood tree is a reminder that Highgate was developed within an older landscaped estate.

The later, Eastern section is a more conventional cemetery-cum-woodland, enriched with flowers and shrubs, which has become an informal shrine to Karl Marx, buried there and marked with a larger-than-life bronze bust.

Even before you arrive, the approach up or down narrow Swain's Lane is essentially unchanged since the mid-nineteenth century. Be prepared to pre-book your tour for the West cemetery, the East has un-guided access. Both have entry charges.

Don't Miss

- The historical display in the chapel.
- The Terrace catacombs and Julius Beer's sumptuous mausoleum.
- Animal sculptures: Wombwell's lion, Tom Sayers' mastiff dog, and the Atcheler little horse.
- The columbarium (depository for early cremated remains).
- The more 'open' Eastern cemetery with Karl Marx's powerful 'presence'.

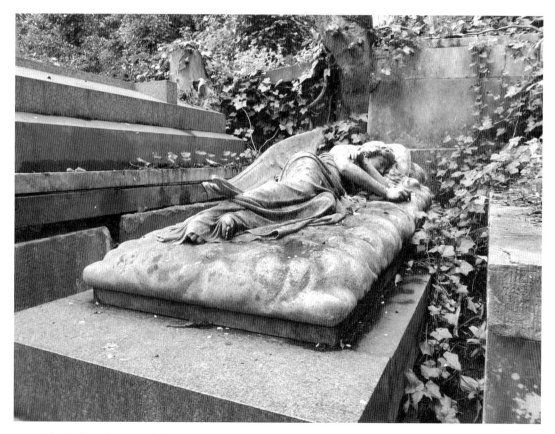

A bed of grief: a remarkable achievement in marble.

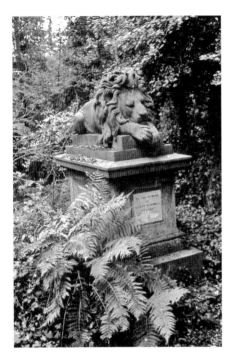

Highgate has iconic memorials featuring animals; this is George Wombwell's lion (see Palace of Varieties p. 128).

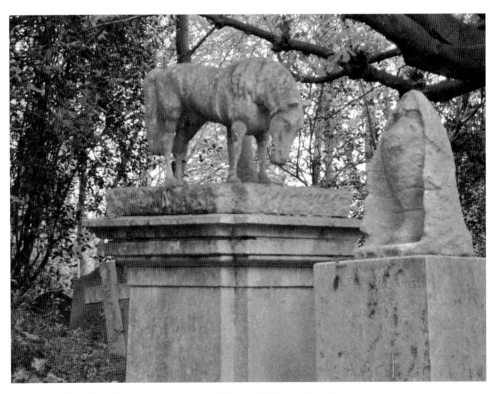

John Atcheler's little horse. He was Queen Victoria's horse slaughterer.

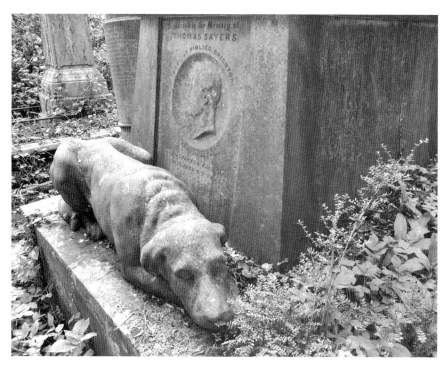

Thomas Sayer's mastiff dog (see Bare-knuckle Superstars p. 130).

Nothing can prepare you for Highgate's *coup de théâtre*, the Egyptian Avenue entrance with internal vaults.

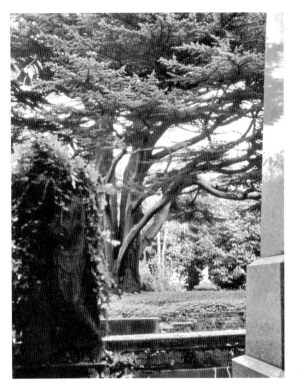

A venerable cedar of Lebanon is key to the original landscape design.

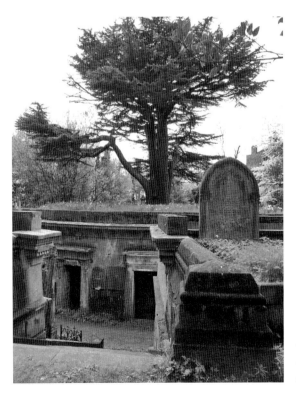

The tree is retained within a circle of vaults which face a much larger circle of burial chambers.

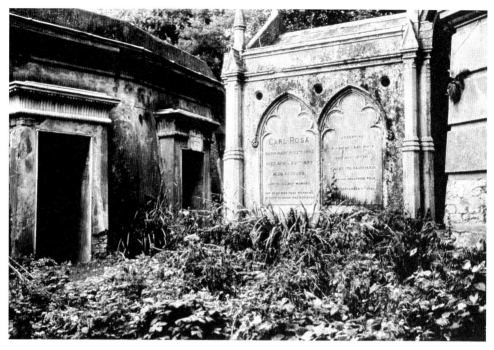

A Gothic-revival intervention in this largely Egyptian/Classical-revival scheme is the tomb of Carl Rosa, opera impresario (*d.* 1883).

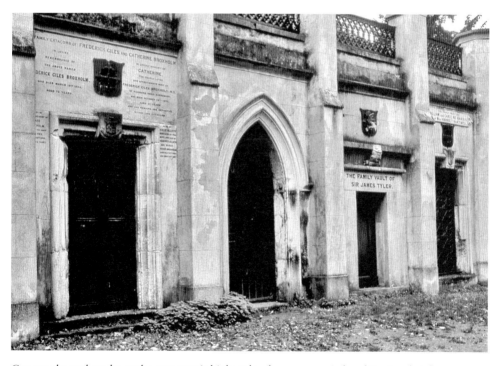

Catacombs and vaults at the cemetery's highest level express varied architectural styles.

Hall of Fame

Highgate's continuing popularity as a last resting place has ensured that notable names from the twentieth and twenty-first centuries can be remembered along with those from earlier times.

Women writers are well represented, and include: **George Eliot** (*d.* 1880), pseudonym of Mary Ann Cross, author of *Middlemarch* and *Mill on the Floss*; **Marguerite Radclyffe-Hall** (*d.* 1943), whose *Well of Loneliness* dealt with lesbianism; **Stella Dorothea Webb** (*d.* 1989), pseudonym Stella Gibbons, poet and novelist, author of *Cold Comfort Farm*; **Christina Rossetti** (*d.* 1894), poet and writer, including *Goblin Market* and *In the Bleak Midwinter*.

William Friese-Greene (*d.* 1921)
Cinematograph pioneer and patent-holder.

Sir Ralph Richardson (*d.* 1983)
An eminent stage and film actor.

Feliks Topolski RA (*d.* 1989)
Distinctive painter and illustrator represented in many London collections.

Julius Beer (*d.* 1880)
Banker; his tall extravagant mausoleum is a prominent part of the Western cemetery's architectural ensemble.

Frederick William Lillywhite (*d.* 1854)
Outstanding cricketer, first round-arm bowler, played for England.

Jacob Bronowski (*d.* 1974)
Scientist, humanist and broadcaster, notably with *The Ascent of Man* on TV.

Claudia Jones (*d.* 1964)
Black rights campaigner who started the Notting Hill Carnival.

Karl Marx (*d.* 1883)
Philosopher, writer, father of Marxism; his massive head-and-shoulders memorial in the Eastern cemetery draws many visitors from around the world.

Stephen Geary (*d.* 1854)
Founder and chief planner of Highgate cemetery; also produced a huge statue of King George IV, which stood at King's Cross.

Michael Faraday (*d.* 1867)
Scientist (see entry under Eureka! p. 126).

Paul Foot (*d.* 2004)
Journalist, socialist writer and campaigner.

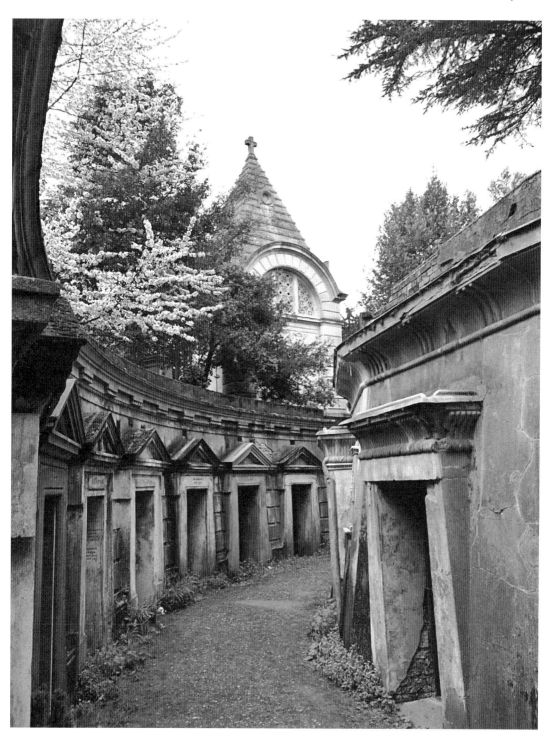

Above the Circle of Lebanon is a further terrace, dominated by the white mausoleum of banker Julius Beer, here flanked by spring blossom.

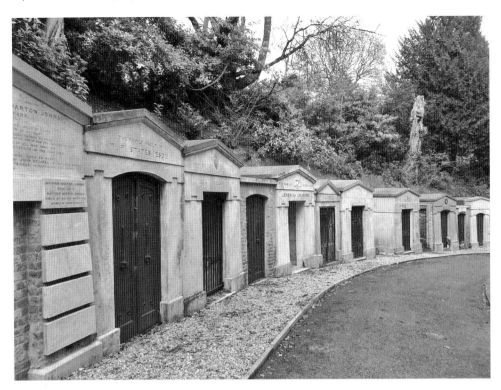

Near to entrance level can be seen this terrace of modest mausolea designed for Non-conformist (or Dissenting) families.

In the more accessible Eastern section of Highgate, summer wild flowers are encouraged and enhance the carved lilies above.

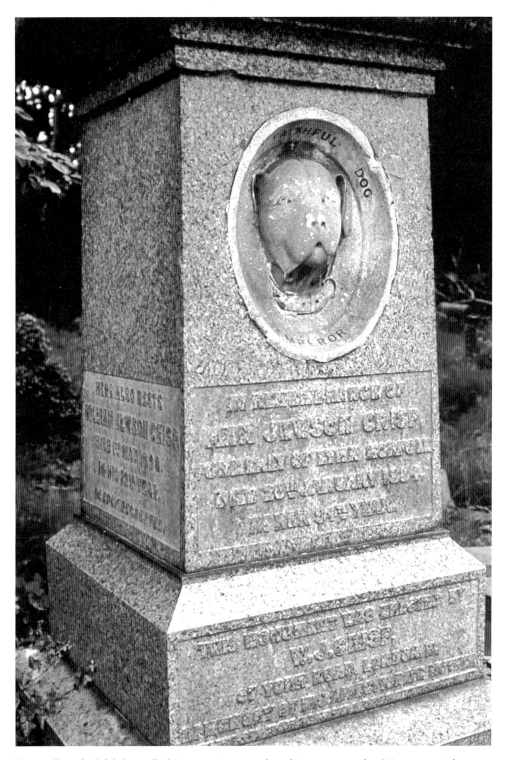

Unusually, a faithful dog called Emperor is remembered in cameo on the Crisp memorial.

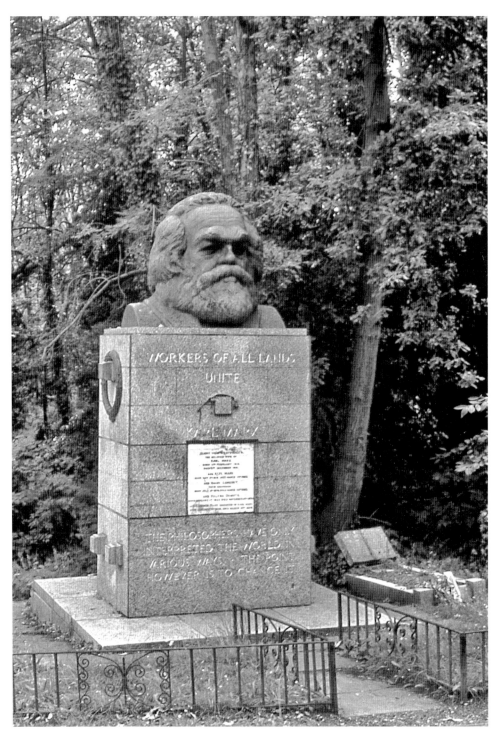

The best known grave at Highgate is that of Karl Marx, bearing the legend 'Workers of all Lands Unite'.

Detail of the Egyptian Avenue columns.

NUNHEAD CEMETERY

Location: Linden Grove, London, SE15
Founded: 1840 by the London Cemetery Company
Extent: 53 acres
Owners: London Borough of Southwark (since 1975)
Access: daily free access
Friends Group: Friends of Nunhead Cemetery; tours at 2.15 p.m. on last Sunday of each month (free). www.fonc.org.uk
Landscape, neoclassical entrance piers and lodges (one derelict) are by James Bunstone Bunning, architect.

Anglican chapel in decorated Gothic style (architect Thomas Little), partially restored following arson.

English Heritage listed cemetery Grade II*; recipient of £1.25 million Heritage Lottery award in 1998.

Space for a small number of burials still remains.

A Snapshot

Even today the cemetery is in a quiet backwater of south-east London. Standing at the restored cast-iron entrance gates, the prospect is both grand and inviting. Beyond the lodges and a circular flower bed, a wide avenue edged in knapped flint and flanked by mature lime trees offers a diminishing perspective to the imposing porte-cochère of the chapel.

At either end of the main avenue, paths at right angles lead east and west – but not for long as this axial layout gives way to winding and circuitous routes that take advantage of the perimeter, the hillsides and the airy hilltop with dramatic views.

An initial impression is of total woodland – by no means the case, though the extensive site is a major secondary woodland for inner-London, and a classified nature reserve. A wide selection of wild and naturalised flowers can be enjoyed through the year.

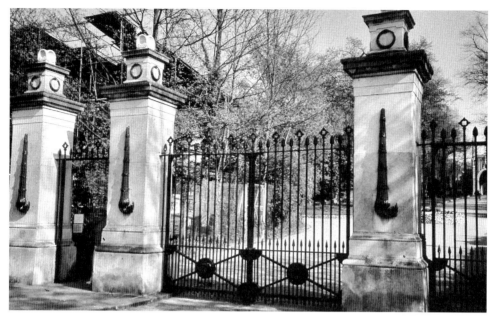

The restored gates at Nunhead cemetery; on the piers are upturned torches symbolising life extinguished.

The snake or serpent circle is an eternity symbol probably from ancient Egypt.

A restoration programme in 2000
(Heritage Lottery funded) included
rebuilding this flint circle at the start
of the lime tree avenue leading to the
Anglican chapel.

Of the twin neoclassical lodges, one is restored, the other derelict. This rooftop view shows that
the chimney stack is modelled on a classical tomb (see A Palladian Council House p. 82).

Ernest Brackley, gatekeeper in the early decades of the twentieth century, was a familiar figure. He died in 1956 and is buried near the main gates. The flower stall was a sideline.

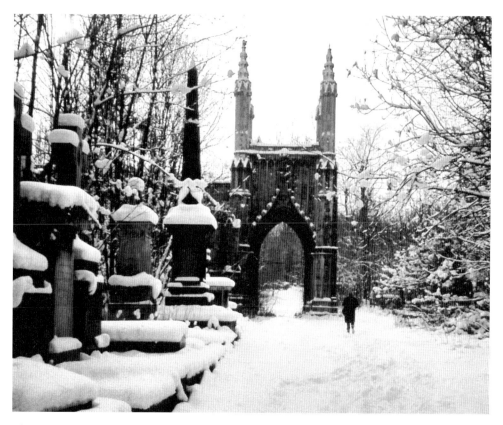

The octagonal Anglican chapel, Gothic-revival style, is dominated by a finely detailed *porte-cochère*, under which the coffin would be transferred from the hearse to the chapel. Snow highlights some details.

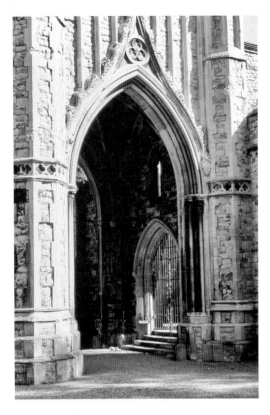

The gates into the chapel date from the partial restoration in 2000.

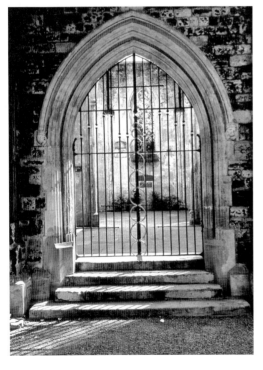

This view into the octagonal chapel shows that it is still roofless. The Friends group participated in the design of the new gates, which recall the snake motif from the main gate piers.

Below the chapel, a new door serves the restored crypt.

The crypt walls are lined with compartments or *loculi* for coffins.

Don't Miss

- A tree-framed vista of St Paul's Cathedral, some 5 miles away, from the High Point (200 ft above sea level).
- The splendid silver-grey granite memorial to ship owner John Allan with fine bronze relief work – reputedly based on a Lycian mausoleum brought to the British Museum.
- A Muslim burial area has been provided, and there are Commonwealth War Grave sites.
- The Scottish Martyrs obelisk (a copy of one at Calton Hill, Edinburgh) to five lowland Scots transported to Australia in 1793 for advocating parliamentary reform.

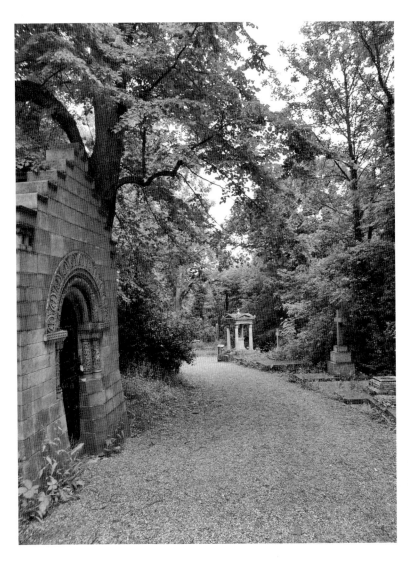

The Figgins' family memorial (a small classical temple) marks a major path junction.

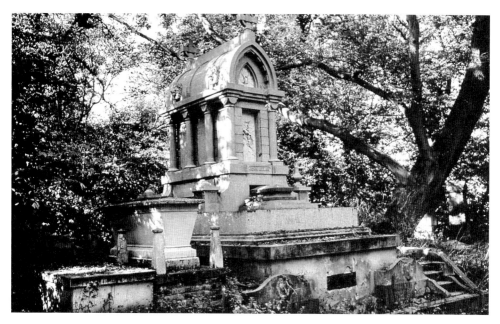

The silver granite memorial to ship owner John Allen (*d.* 1865) is said to be a reworking of the ancient Payava tomb, shipped around that time from Xanthos to the British Museum.

Detail showing two of the four bronze lion heads.

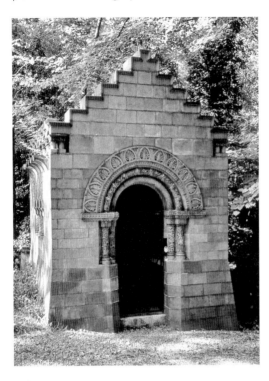

Nunhead's surviving mausoleum was constructed in 1902 by Doulton of Lambeth, Romanesque in style with Celtic motifs, for the Stearns family of Twickenham.

Detail of the replica gate and terracotta moulding.

Hall of Fame

Thomas Tilling (*d.* 1893)
London omnibus pioneer and magnate, who also operated hansom cabs. He also supplied horses to the fire brigade, police and the Royal Household, owning some 7,000 horses at his death.

Bryan Donkin (*d.* 1855)
Engineer, and inventor of an airtight metal can for preserving food. His son, another Bryan (same vault) built a banknote factory in Russia.

Jenny Hill (Woodley) (*d.* 1896)
Music hall singer, noted for 'The boy I love is up in the gallery'.

Sir Charles Fox (*d.* 1874)
Railway engineer, responsible for lines, bridges and tunnels around London. In addition, he was a contractor for the Great Exhibition of 1851 and the Crystal Palace at Sydenham.

Joseph Myatt (*d.* 1855)
A market gardener, whose south London farm is now Myatt's Fields Park. Popularised rhubarb at Covent Garden market, and raised the strawberry varieties British Queen and Deptford Pine; died at Manor Farm, Deptford.

Sir Polydor de Keyser (*d.* 1898)
London hotelier, City Alderman and Sheriff; he was the first Roman Catholic Lord Mayor since the Reformation.

John Moritz Oppenheim (*d.* 1864)
Skin and fur merchant in East London, patron of the arts though blind during the last twenty years of his life. His large Grecian monument has relief carving on its sides.

Sir George Livesey (*d.* 1908)
Trained as an engineer and rose to become chairman of the South Metropolitan Gas Company. An enlightened employer, he introduced profit sharing and paid holidays, also providing a working men's club, a library and a park in south London.

John Wade (*d.* 1863)
Called the 'Good Samaritan of Deptford' for his good works and fearless opposition to social injustice, leading to the abolition of the Church Rate in that parish, and fighting for better pay for dockyard workers; during the cholera epidemic of 1854 he raised sums of money for widows and children.

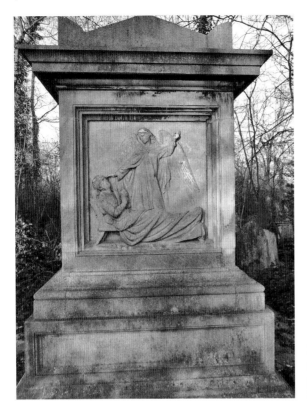

Dramatic relief carving: an angel touches the eyes of blind philanthropist John Moritz Oppenheim.

Frederick Rogers (*d.* 1915)
Trade unionist, pioneered old age pensions and workers' education; writer and popular speaker on literature, politics and religion; buried first in a common grave before being moved to a private one, and his achievements recorded there.

Thomas Earp (*d.* 1893)
An architectural sculptor who left his mark on churches by Barry and Street, and in Magdalen College chapel, Oxford. His most visible work is the tall Eleanor Cross in the forecourt of London's Charing Cross station (erected 1863).

The Baden-Powell Connection

In August 1912 an open boat taking Boy Scouts from Walworth, south London, to their campsite was capsized in a squall in the Thames estuary off the Isle of Sheppey (their destination). Despite heroic rescues, nine boys drowned. The first Lord of the Admiralty, Winston Churchill, authorised a warship to convey the bodies back up the Thames.

Such was the respect at the time for Lord Baden-Powell's new Scout movement that the tragedy deeply affected the nation and south London in particular. Thousands filed

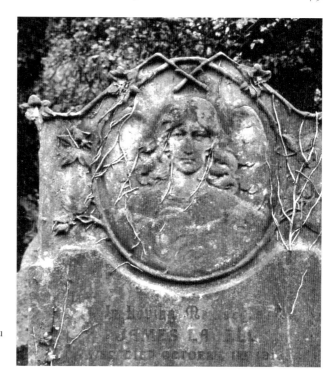

Pre-Raphaelite and art-nouveau styles are evoked on the headstone of James Lavell.

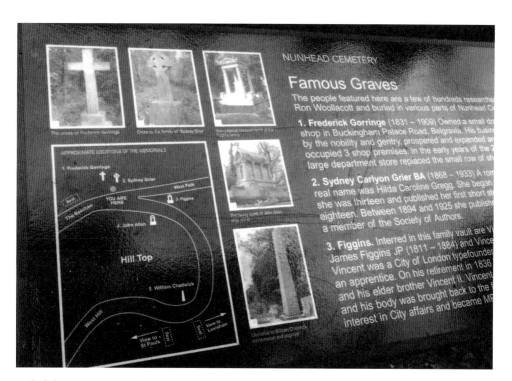

Helpful interpretation boards have been provided at key points by Southwark Borough Council.

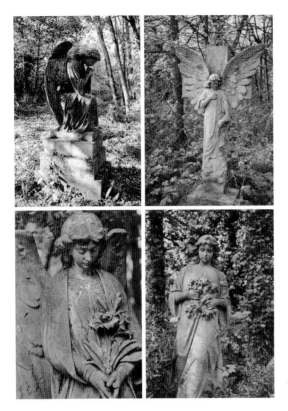

Angelic figures at Nunhead (top and bottom left © FONC).

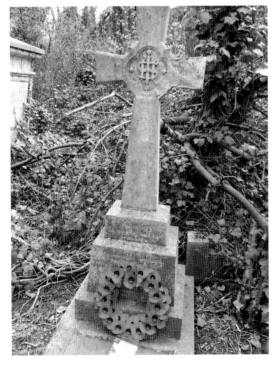

Fred Rogers (*d.* 1915) was a working class polymath who strove for the introduction of the Old Age Pension. His achievements are here recognised by a poppy wreath.

past the coffins in St John's Church, Walworth, and unprecedented crowds lined the 3-mile route to Nunhead cemetery.

National newspapers gave extensive coverage to the funeral, and the *Daily Express* promoted a memorial fund. Newsreel film footage of the event also survives.

In 1914, a cenotaph designed by Sir Giles Gilbert Scott was erected over the communal graves of the Scouts, fronted by a life-size bronze figure of a scout, the work of Lillie Reed.

This fine memorial was tended by local Scouts until, in the late 1960s, during a period of severe vandalism in the cemetery, the bronze figure was hacked down one night for its scrap value. Following this loss, the cenotaph was dismantled, the site neglected and the story nearly forgotten.

A chance conversation between an elderly man and a member of the Friends group was to open a new chapter. He recounted that as a small boy he had been standing near the cemetery when the long cortège passed. The Friends resolved to honour all these events, resulting in the donation and inscription of a marble stone in the shape of an open book recording the names of the drowned boys, and updating the story.

Thus in 1992 a rededication service took place with Scouting, local churches, civic and Parliamentary representation. The new stone stands at the original site, where once the bronze figure stood alone, until flanked by memorial stones to young Commonwealth casualties of the 1914-18 Great War; a poignant choice of location.

A complete illustrated account of the above events can be found in *The Walworth Scouts* by Rex Batten, 2003, from the Friends group.

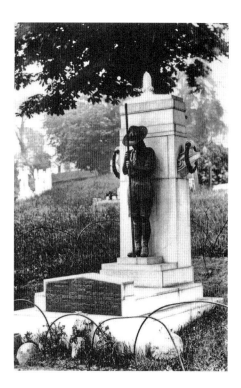

Photographed prior to theft and destruction in the 1960s, the cenotaph and bronze life-size Boy Scout were a landmark in Nunhead (© FONC).

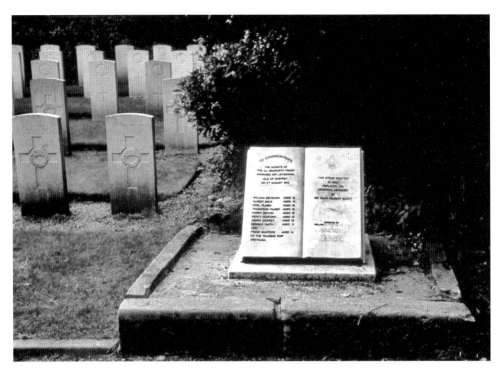

Next to the replacement memorial to the drowned Scouts can be seen 1914-18 Commonwealth War Graves headstones to servicemen from Canada, South Africa and New Zealand.

A Palladian Council House

Following its purchase of Nunhead Cemetery for a nominal £1 in 1976, Southwark Borough Council made the semi-derelict neoclassical West Lodge inside the main gates habitable again. Twin lodges by the architect James Bunning were a highlight of the original design. There is a sunken lower ground floor, so that the front façade is a raised single storey with the pleasing proportions of a classical villa.

Remaining internal features from the nineteenth century were stripped out when the building was 'rescued'. The selected tenant of the refurbished 'council house' was an employee who kept large dogs kennelled in the back garden for legitimate 'enforcement' duties elsewhere.

As a Grade II listed building in a Conservation Area, special responsibilities were attached to the owner, but the housing department of the council at the time seemed unaware of such matters. The Lodge would have made a superb centre and museum for the cemetery, possibly run by the Friends group, had a more enlightened approach prevailed.

What happened was that the tenant, as soon as legally permitted, applied to buy the property, and this went ahead again without a quibble. Happy with his rare bargain, the tenant was soon able to offer the Lodge on the open market as a unique private house, this time at the true market price.

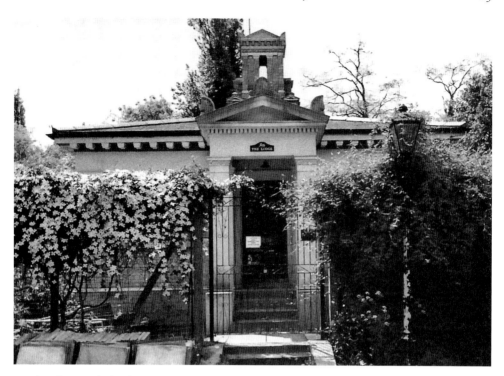

Nunhead's west lodge became a council house after its refurbishment, later sold on as a private residence (© FONC).

Thankfully the purchasers have been responsible custodians of the property, developing a tasteful garden setting. However, they are regularly pestered by visitors who assume they are caretakers with keys.

This cautionary tale of bad but avoidable decisions over cemetery buildings has echoes elsewhere among the Seven in London and in the country at large. Forced sales by cemetery owners, and sudden responsibilities taken on by new owners lacking foresight and funds, have led to even more tragic consequences.

Nunhead's twin East Lodge (actually enlarged at the rear to be residential from the start) was burned out by vandals and languishes within protective scaffolding. The Friends group is struggling to raise funds for its restoration, but when this happens – as it must – these pretty buildings will be bright jewels in the diadem of the Seven.

ABNEY PARK CEMETERY

Location: Stoke Newington High Street, London, N16 0LN
Founded: 1840 by The Abney Park Cemetery Company
Extent: 32 acres
Owners: Abney Park Cemetery Trust, www.abney-park.org.uk
Access: daily free access
Friends group: Friends of Abney Park (address above)

The name derives from an eighteenth-century estate covering a larger site, held by the Abney family, whose religious views were Non-conformist. Parts of these grounds, and also some of neighbouring Fleetwood House grounds, were developed for the cemetery.

Architect to the cemetery was William Hosking, whose Egyptian-funereal entrance pylons and lodges remain an impressive unity. The centrally located chapel – unique among the great cemeteries in being non-denominational – is cruciform with a spire, in Gothic style, and built in brick. Though in a sad state, it is by no means a ruin. Established by Dissenters, albeit open to all, the cemetery was effectively the successor to Bunhill Fields (see How it all Began... p. 12). It was richly tree-planted even before the laying-out of the cemetery (landscaped by George Loddiges), and it remains densely covered. Silver birch trees thrive in the sandy soil.

The Trust promotes an education centre as well as a visitor centre based on the two Egyptian-revival lodges. An activity of direct value to the cemetery is a stone-carving workshop where courses are run. A short section of the Capital Ring (a well-signed London orbital walk) passes through the cemetery, linking with Stoke Newington train station.

A Snapshot

A peaceful village it might have been in 1840, but the roads that now follow two sides of Abney Park cemetery are noisily urban, and quite an urban tide uses the place as a short cut or somewhere to hang out. The trees are still wonderful, the network of paths is kept tidily open, and ivy is less evident in the woodland than in some of the Seven.

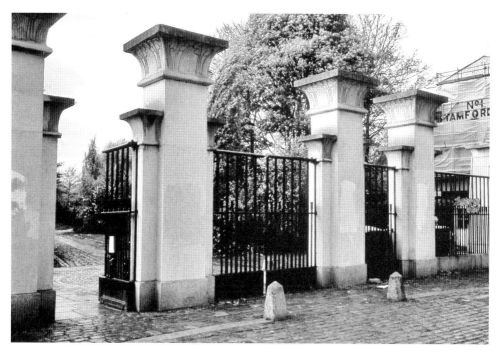

Abney Park's gate piers and lodges retain their Egyptian-revival iconography.

Detail from the side of a lodge.

The multi-denominational chapel in an early spring view; brick built it is largely intact externally.

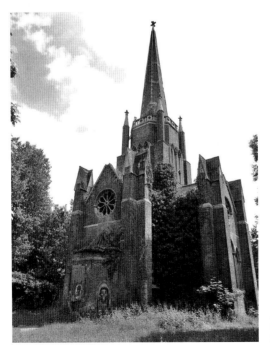

From the rear or apsidal end it resembles a mini-cathedral.

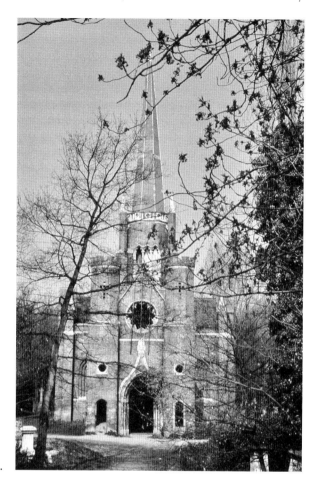

The pointed arch of the *porte-cochère* resembles that at Nunhead.

While many of the graves and monuments are modest, as befitted Non-conformist principles, there are notable exceptions, including a lugubrious lion and a larger-than-life statue of the hymn writer Isaac Watts (who resided with the Abney family at one time, and is actually buried at Bunhill Fields).

It would be wonderful if the chapel – not unlike a mini-cathedral – could be saved from further deterioration, and perhaps put to some community use, in line with plans already developed by the Trust.

Don't Miss

- The ancient Egyptian motifs on the cornice of the office lodge.
- The shield-shaped memorial to the founder of the Salvation Army – William Booth.
- A substantial monument to John Spreat, merchant, designed by the artist and architect Alfred Waterhouse (near the chapel).
- A poignant assemblage in stone of a chief fire officer's helmet and clothing; superintendent James Braidwood (*d.* 1861) was killed in a burning warehouse.

Not beyond restoration, the tracery of a circular window.

Closely linked with the cemetery, is the eighteenth-century hymn writer Isaac Watts, whose huge statue is central.

Hall of Fame

'General' William Booth (*d.* 1912)
Founder of the Salvation Army in 1878; also buried here is Catherine, his wife (*d.* 1890), Bramwell their son (*d.* 1929) and daughter Florence (*d.* 1957). The 'Army' gave equal status to women, and brought practical Christianity to city streets (along with rousing band music and singing). It was said of William Booth that 'no modern man has touched so many wretched lives all over the world'.

The dates for **Mary Hillum** are uncertain, but she died aged 105 in Church Street, Stoke Newington, in the house in which she was born, never having travelled by omnibus or railway for more than 15 miles from home.

Samuel Morley (*d.* 1886)
Hosiery manufacturer, MP for Nottingham, worked for Dissenters' causes, and endowed Morley College, South London, for adult education.

Frank Bostock (*d.* 1912)
Menagerist, the term for a circus or zoo proprietor; a mighty but docile lion tops his tomb.

Revd Walter Medhurst (*d.* 1857)
A missionary in China for forty years, author of a Chinese-English dictionary, and translated the Bible into Mandarin.

Revd Dr John Pye-Smith FRS, FGS (*d.* 1851)
Theologian and scholar; he was the first Dissenter to be formally accepted as Fellow of the Royal Society, and also of the Geological Society. His views on geological time caused controversy among those who took the Bible literally.

Sir Charles Reed (*d.* 1881)
He was the first Member of Parliament for Hackney, and chaired the School Board for London, providing publicly funded education. By profession a printer and type founder, he was a director of the Abney Park Cemetery joint stock company, and chaired the Bunhill Fields Preservation Committee.

Conrad Loddiges (*d.* 1865)
Third generation of eminent nurserymen of Mare Street, Hackney. Their lease expired and the valuable land went for housing. The final sales of orchids and other exotic plants attracted the sort of crowds now associated with the Chelsea Flower Show.

Joanna Vassa (*d.* 1857)
Her father was Olaudah Equiano alias Gustavus Vassa, an African slave who, freed in England, became a famous author and Abolitionist. She married a Congregational minister. (see The Wilberforce Connection p. 94)

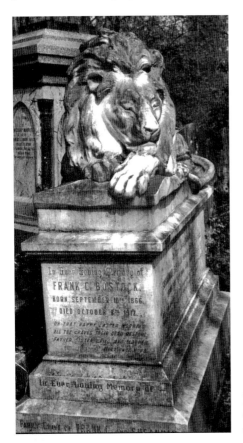

Frank Bostock was a famous animal trainer and exhibitor who died in 1912. A sleeping lion covers his tomb.

This beautifully conserved marble memorial records the death in 1861 of James Braidwood, superintendent of the London Fire Engine Establishment, while fighting a terrible fire in Southwark.

A memorial stone with a weeping widow/weeping willow design, coupled with superb carved lettering, a style chosen in the first decade in some of the Seven.

A literal symbol of the 'wings of time' is seen in this rare carving of an hourglass with bat-like wings on either side.

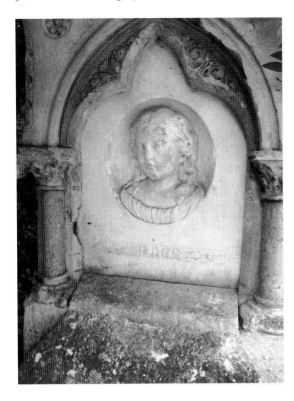

Bearing the name Agnes, this emotive child's head has traces of colour in the eyes and cheek.

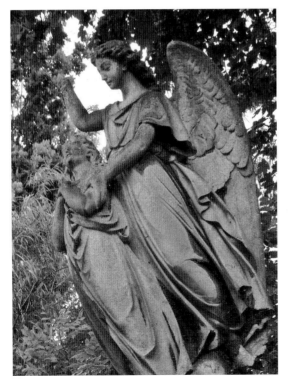

An angel guides the deceased soul heavenwards, represented by the body.

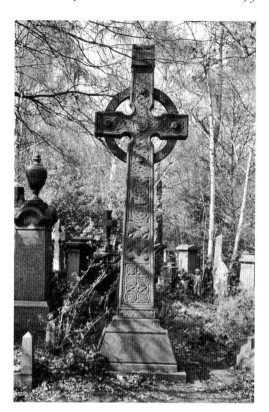

Standing tall among Abney Park's birch trees is a massive Celtic cross, a popular nineteenth-century form of Christian remembrance.

A newly-surfaced path leads invitingly around the cemetery.

A surviving example of symbolic ironwork around an early grave.

The Wilberforce Connection

William Wilberforce is the name most closely associated with the campaign for the Abolition of Slavery, which began in 1788 and achieved Parliamentary approval shortly after his death in 1833.

Abney Park cemetery is the resting place of many Christian Non-conformists who fought the same fight against slavery. One iconic figure is Joanna Vassa (*d.* 1857), daughter of Olaudah Equiano (slave name Gustavus Vassa). After gaining his freedom in 1766 he settled in London, becoming a famous author and abolitionist – writing from his own experiences. Olaudah enjoyed the patronage of Selina, Countess of Huntingdon, who when young had known Lady Mary Abney. Joanna married the Revd Henry Bromley, though her grave bears her father's name.

Revd Dr Thomas Binney (*d.* 1874), known as the 'archbishop of non-conformity', was also active in the abolitionist cause, as was Thomas Burchell, Baptist missionary, whose house in Jamaica is owned by the Jamaican National Heritage Trust.

Thomas Canry Caulker (*d.* 1859), was the son of the king of Bumpe (now in Sierra Leone), sent to England for an Evangelical education. His father drew up an agreement with the British allowing ships from his kingdom to be intercepted and checked for slaves.

Among others buried at Abney Park who promoted anti-slavery campaigns are the Revd Newman Hall and Revd James Sherman (active in the USA), and the Revd Aaron Buzacott, associated with abolition in the Ottoman Empire.

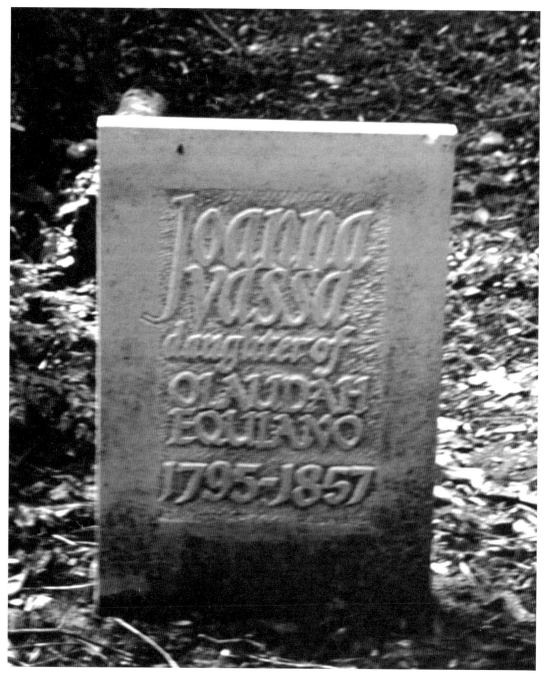

Joanna Vassa was the daughter of former slave Olaudah Equiano. There is a stone carving workshop at Abney Park adding to permanent historical records.

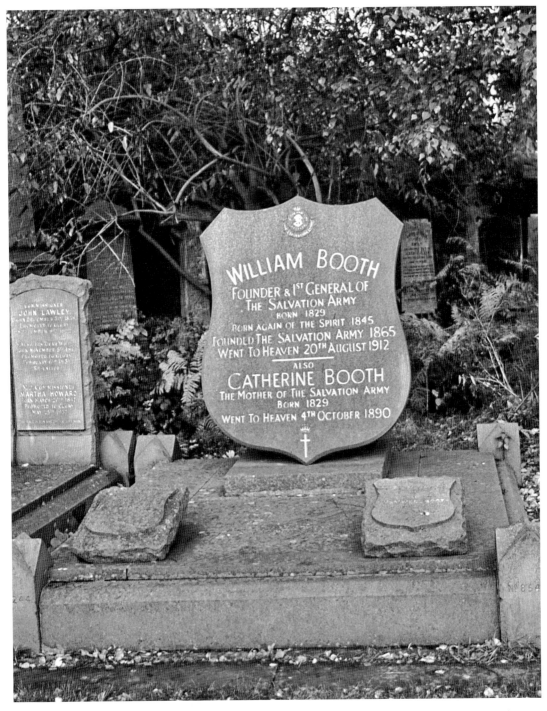

Generations of Booths and other officers of the Salvation Army are buried and commemorated at Abney Park – a mecca for Christian Non-conformity.

BROMPTON CEMETERY

Location: Old Brompton Road, London, SW10 9UG (to Fulham Road in the south)
Opened: 1840 by West London and Westminster Cemetery Company
Extent: 39 acres
Owners: Crown Estates, managed by The Royal Parks
Access: daily free access
Friends Group: Friends of Brompton Cemetery, tours T 020 7351 1689

 A grand design of neoclassical elements by Benjamin Baud (pupil of Wyatville) that was never fully realised, takes the symmetrical ground-plan of a vast basilica covering the long, narrow site. Thus a wide central axis of some 600 metres leads via a great circle to the Anglican chapel – a domed rotunda. Arcades flank the chapel, with catacombs below.

 This remains a working cemetery.

A Snapshot

Be surprised by the location, as this is by far the most central of the Seven. At the western edge of Kensington it still manages to preserve the special tranquillity shared with its sister cemeteries. The layout is intentionally formal – you are not likely to get lost – though the edges are well-clothed with trees, shrubs, grasses and wild flowers. The Royal Parks' Brompton Cemetery guide lists fifty distinct trees and plots them on a plan.

 Within the strong grid plan, fine memorials and themed groups are scattered; among the latter can be found Victoria Cross holders and memorials to the Brigade of Guards and the Chelsea Pensioners. Some 2,600 Pensioners were interred during the second half of the nineteenth century.

 Monuments of sculptural merit include realistic winged putti on a pedestal for the Schloss family, and a bravura figure of a youth scattering flowers accompanied by books on the Sangiorgi tomb.

Passers-by on the Old Brompton Road glance through the neoclassical entrance and down the long tree-lined axis of the cemetery.

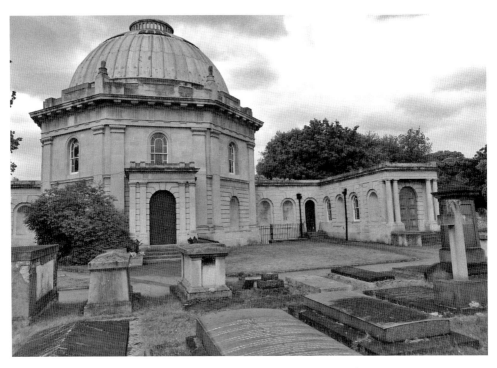

The domed octagonal Anglican chapel is built of warm Bath stone – this is a rear view.

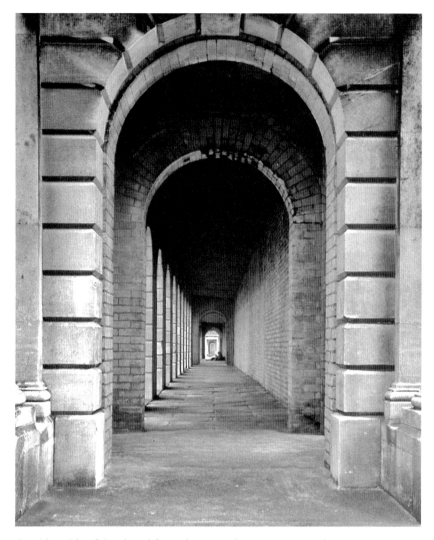

On either side of the chapel front, long arcades cover catacombs.

Don't Miss

- Artists with Kensington connections including Valentine Prinsep, and the 'Romanesque shrine' with bronze arabesques for Frederick Leyland, patron of the Pre-Raphaelites, designed by Edward Burne-Jones, both are Grade II listed.
- A melancholy lion atop the fine memorial to prize-fighter John 'Gentleman' Jackson (Grade II).
- Doom-laden gates to the catacombs with inverted torches and encircling fierce serpents.
- Twelve holders of the Victoria Cross are buried here.
- Graves of high ranking members of the Polish military and two prime ministers.

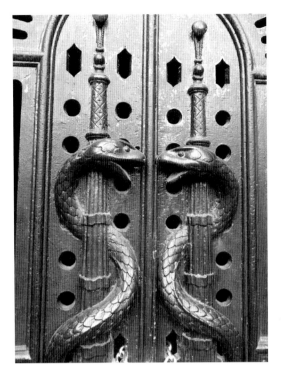

A few steps down bring you to the formidable doors that guard the catacombs on either side; they bear symbols of death and new life.

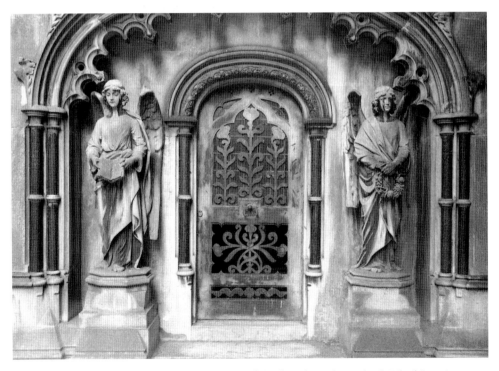

James McDonald (*d.* 1915), Scottish born, one of the founders of Standard Oil of America, rests in this grand mausoleum decorated with Gothic and later elements.

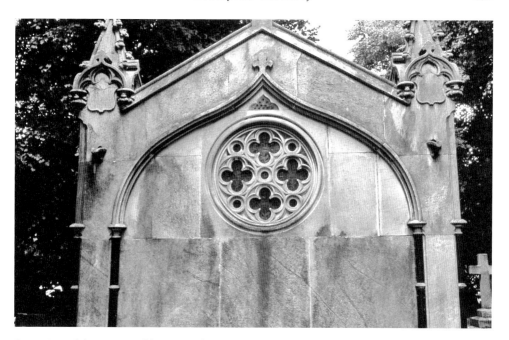

Rear view of the McDonald memorial.

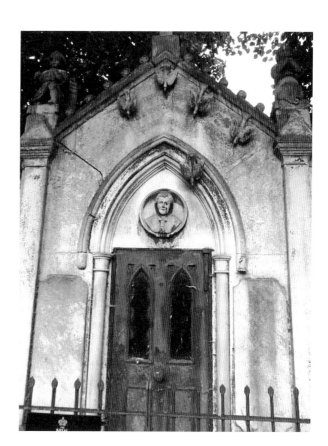

Decaying but evocative, the Woolly/Phillips mausoleum displays a cameo portrait and descending birds signifying the Holy Spirit.

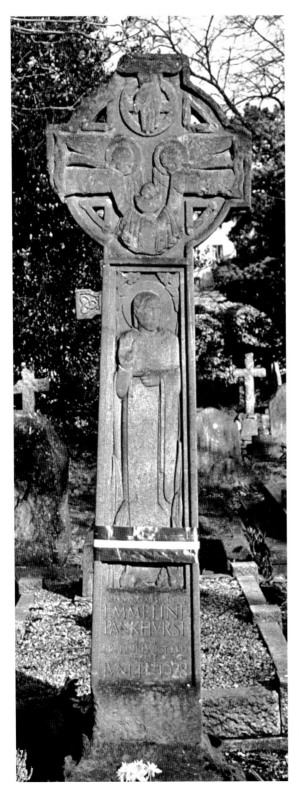

A Modernist version of the Celtic
cross records the death, in 1928, of
Emmeline Pankhurst, suffragette
leader, who lived to see many
women's rights granted.

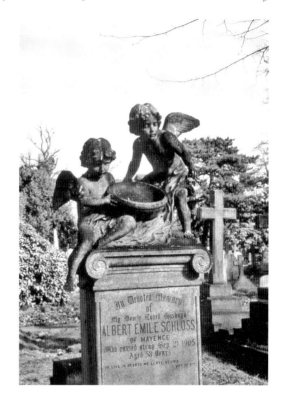

Warming the hearts of visitors to
Brompton since 1905, these winged putti
grace the memorial to Albert and Emile
Schloss.

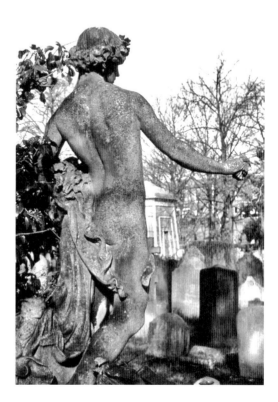

A lightly veiled youth scatters emblematic
flowers in this virtuoso sculpture on the
Sangiorgi grave.

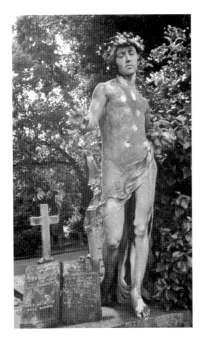

The detail in the face expresses great sorrow.

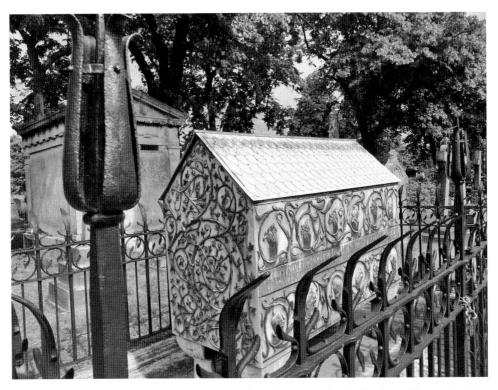

Possibly Brompton's most treasured memorial is that to Frederick Leyland (*d.* 1892), ship-owner and patron of contemporary artists. A copper roof and bronze arabesques cover a marble 'shrine', designed by Edward Burne-Jones.

Detail of the bronze arabesques.

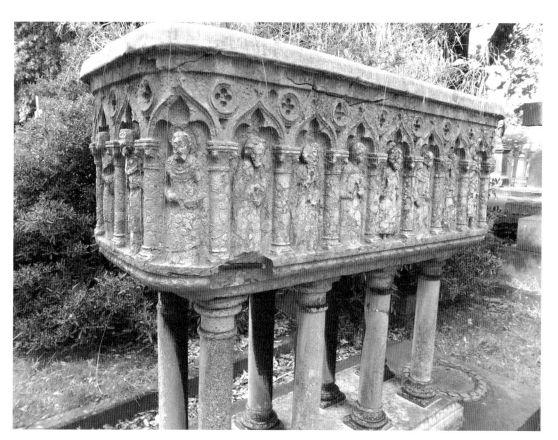

Deterioration of this supposedly thirteenth-century sarcophagus reveals it to be a fake. It came from Italy to commemorate Valentine Princep, an artist close to the Pre-Raphaelites.

Hall of Fame

Richard Tauber (*d.* 1948)
Probably the best loved tenor voice of his generation. An Austrian who fled the Nazis in 1931, he regularly sang at Covent Garden.

Emmeline Pankhurst (d. 1928)
Suffragette leader who lived to see equal voting rights for men and women, she also helped secure property rights for married women. Her Celtic cross memorial has a modernist carving.

John 'Gentleman' Jackson (*d.* 1845)
A bare-knuckle prize-fighter who became proprietor of a self-defence school in London's select Bond Street, and a competent wood engraver. The Grade II monument was erected by public subscription.

Sub Lieutenant Reginald Warneford (*d.* 1915)
Incredibly, he attacked and destroyed a heavily armed large German airship, with five hand grenades and a pistol from his small canvas-covered monoplane. Some twelve further holders of the VC are buried at Brompton.

Sir Henry Cole (*d.* 1882)
A true Renaissance man of the Victorian age – a writer, painter, music critic, designer (including postage stamps); he established the Public Record Office; was an entrepreneur in the fields of sewage processing and cheap newspapers; edited the *Journal of Design*; championed the 1851 Great Exhibition, the Victoria and Albert Museum, the Royal Albert Hall and the Royal College of Music. He was married with eight children.

John Wisden (*d.* 1884)
Sussex and All-England cricketer; founder of *Wisden's Almanack*.

Robert Coombes (*d.* 1860)
Supreme rowing champion on the Thames and the Tyne – winner of Doggett's Coat and Badge seven years in a row – his monument has carved figures displaying these achievements (defaced by vandals), and an upturned skiff. His funeral halted shipping in the Pool of London.

Sir Samuel Cunard (*d.* 1865)
Canadian who progressed from whaling ships to a trans-Atlantic steam mail service and a great passenger service, which bore his name.

Chief Long Wolf (*d.* 1892)
Led his tribe in the Sioux wars but died in Europe touring with Buffalo Bill's Wild West Show.

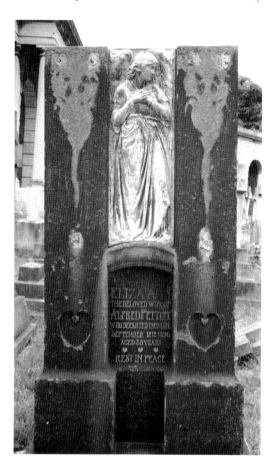

Sympathetic to the art-nouveau style, this angelic image has lost its flanking metal panels.

Here an angel seems to guide children into the unknown on the Sotheby memorial.

Orchestral conductor Alfred Mellon (*d.* 1867) lies below this unusually tall memorial. His wife, Shakespearean actress Sarah Jane Woolgar is named on a simple adjacent stone.

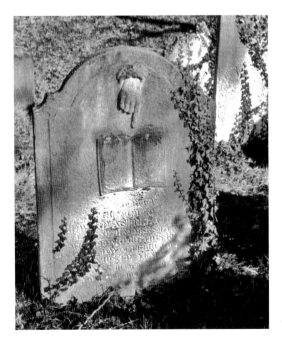

The finger of God indicates Holy Writ.

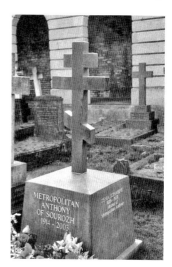

Brompton is home to many faiths, and in a section with Orthodox burials can be found the grave of much-loved Metropolitan Anthony Bloom.

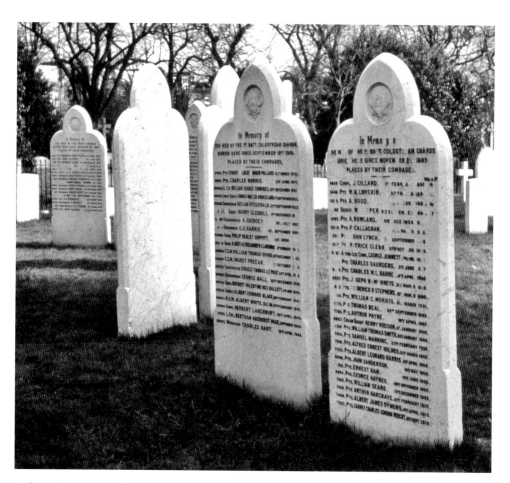

Military history is well recorded at Brompton, these white memorials honouring members of the Coldstream Guards.

This monument to the Pensioners of the Royal Hospital, Chelsea, records that 2,625 were buried in the area between 1855 and 1893.

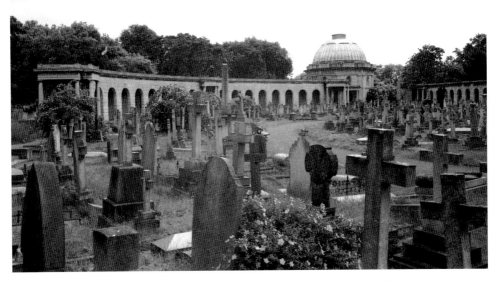

Brompton's original design envisaged an open circle between the arms of the colonnades but commercial pressure resulted in burials being crowded into the space.

Not far away there is more open space, and a crow sunbathes.

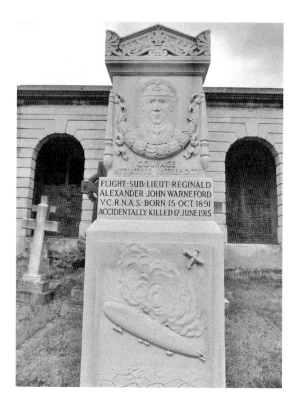

Accidentally killed: the bald statement here barely hints at the amazing event that led to Reginald Warneford's posthumously awarded Victoria Cross.

Imperial Russian royalty and aristocracy, who died in exile, are grouped in a distinct area and include Princess Violette Lobanov-Rostrovsky (*d.* 1932), Countess Vera Wolkoff (*d.* 1942), Prince Alexandre Bagration (*d.* 1955) and Prince George Galitzine (*d.* 1992).

The Beatrix Potter Connection

The universally loved author and illustrator of children's fiction – Peter Rabbit being her most popular creation – lived as a girl in fashionable Kensington in the 1870s, adopting the Lake District only as an adult.

Beatrix had the high Brompton cemetery walls and a multitude of graves as near neighbours, and they seem to have made a deep impression on the sensitive – and possibly lonely – child.

It is claimed that the names of several characters in her stories can be traced from cemetery records, and the walls themselves could have been an inspiration for Mr MacGregor's walled garden, which Peter Rabbit penetrated with temerity.

One easily spotted headstone bears the name Nutkins (a nice name for a squirrel), and there are records of a Mr McGregor (*sic*), a Peter Rabbett, a Brock and a Jeremiah (Jeremy) Fisher. We can imagine the young Miss Potter making notes and developing characters for future use, perhaps to the amusement of a parent or governess.

This fascinating information was brought to light by research into computerised records of burials by the Friends of Brompton Cemetery.

TOWER HAMLETS CEMETERY

Location: Southern Grove, London, E3 4PX
Founded: 1841 by the City of London and Tower Hamlets Cemetery Company
Extent: 33 acres
Owners: London Borough of Tower Hamlets (as Tower Hamlets Cemetery Park)
Access: daily free access, tours on at least one Sunday per month
Friends group: Friends of Tower Hamlets Cemetery Park,
 www.towerhamletscemetery.org

Last of the Magnificent Seven to be established, the directors included John Pirie, a ship owner, who was Lord Mayor of London at the time. The cemetery flourished, with some 270,000 interments recorded by 1889, but most were in common graves at modest fees. Sadly nothing remains of the early architectural features – the Gothic chapel with cloister and catacombs, the octagonal Dissenters' chapel and the Lodge. Second World War bombing damaged the buildings and destroyed whole areas of graves. Post-war clearances were carried out with the intention of establishing a public park, but this was abandoned in favour of a nature reserve.

A Snapshot

Despite all that it has suffered, Tower Hamlets Cemetery remains a beautiful and evocative place to visit. An ecological and educational trust operates from the Soanes Centre within the cemetery. Together with an active Friends group, this ensures the whole site is well managed. There are numerous interesting headstones and memorials to local dignitaries and East End characters. Tree and shrub cover is dense without being oppressive. While lacking the grandeur of other members of the Seven, Tower Hamlets is an example of good management practice worthy of emulation elsewhere. Glades and meadows developed from war-time bomb sites are colourful with flowers and butterflies through spring and summer.

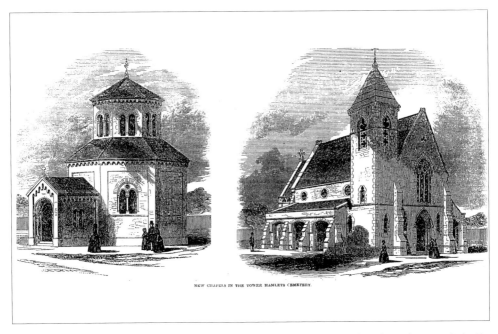

Tower Hamlets Non-conformist chapel (left) and the Anglical chapel (right) when newly built. Sadly they were bomb-damaged in the Second World War and cleared away.

A designated Cemetery Park, Tower Hamlets has clear signage.

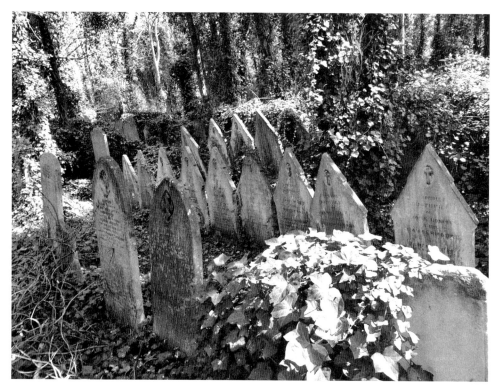

These distinctive pointed headstones have been chosen as the emblem of the Friends group. They mark the graves of former residents of Sutton's Hospital of the Charterhouse at Smithfield, founded in 1613 and still functioning; there are six 'brothers' per grave.

Don't Miss

- Charterhouse graves with pointed headstones record some 200 Brothers of Sutton's Hospital of the Charterhouse (formerly Charterhouse school until its removal to Surrey in 1872), who were distressed gentlemen from the City. Each stone has six names, which is the number buried per grave. Similar charitable work continues to this day.
- The tomb of Charles Francis, merchant and director of the cemetery. A gap in the vault on the east side allowed the rising sun to shine through a pierced wrought iron cross in an iron door on the west side (still in place).
- Charles Jamrach, importer of exotic wild animals which he kept in-transit in premises on the Ratcliffe Highway; escapes were not unknown, and he survived the recapture of a tiger. His grave is near the tall, striking monument to ship and bridge builder, Joseph Westwood.
- The grave of Samuel Soanes, rope-maker, who owned part of the present cemetery land. After his death his wife ran the business for a further thirty-five years. Ropery Street can be found next to the cemetery.
- A millennium wildlife trail is signed around the cemetery.

Hall of Fame

Workers' leaders include **William Crooks** (*d.* 1921), son of a docker, who walked to Liverpool, aged fourteen, to find work; returned and was politically active, becoming the first Labour Mayor of Poplar, then MP for North Woolwich. Also buried is **Henry Orbell** (*d.* 1914), founding member of the Independent Labour Party and organiser of the dock strike committee, 1889.

Joseph Westwood (*d.* 1883), an eminent ship and bridge builder, his tall memorial is English Heritage listed.

Charles Francis (*d.* 1861), corn merchant and a founding director of the cemetery. A missing brick on the east side of the memorial allows the rising sun to shine through holes in a wrought iron cross built into the west side.

Charlie Brown's funeral was attended by huge crowds in 1932. Licensee of the Railway Tavern by West India Dock gates, he collected curios from sailors seeking extra cash – or a free drink! The collection, which included shrunken heads, became a tourist attraction. Trading in antiques became an added interest. He kept a horse (rare in the East End) and graduated to smart cars in the 1920s.

Hanna Maria Purcell (*d.* 1843) is famous through widowhood, being (as the grave inscription reads): 'Relict of one of the last surviving officers of the Mutiny on the Bounty ... forty five days in their boat in the Pacific Ocean ... and having travelled three thousand six hundred miles they landed at Timor where they were most hospitably received by the Dutch Governor.'

East End Disasters

Established near the great London docks, Tower Hamlets cemetery has been close to death through disease, wartime destruction and tragic accident. Some stories are recorded on memorials and graves, others lost, perhaps through the double tragedy of a bomb blast within the cemetery in the Blitz.

Over 600 people were drowned in a collision on the river Thames on September 3, 1871. The cemetery register at the time recorded twenty-three local people 'drowned in the River Thames', and more of the casualties may have been buried there. The boat was the excursion paddle steamer *Princess Alice*, returning from a trip to Southend when she was hit by the *Bywell Castle*, a screw iron collier of 891 tons. The wooden-built steamer was shattered and sank.

Thirteen bodies were buried closely in public graves, and three others have been found. One of these is of John Northey, headmaster of a local school, thought to have taken the trip while the school was having a more local outing. He was forty-two and left a young family of four. An inscription records that the Rector of Limehouse joined

Charles Francis (*d.* 1866) was a corn merchant and director of the cemetery company. In the memorial's raised vault a missing brick on the east side allowed early sun to pass through to a pierced metal cross on the other side, so that it glowed.

Joseph Westwood (*d.* 1883) was a ship and bridge builder; his Gothic monument is the tallest in the cemetery and retains some of its iron surrounds.

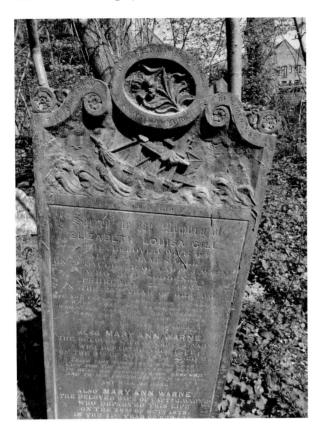

The area had a seafaring tradition as this dramatic carving shows. Just below the ship is inscribed 'Such is Life'.

with the teachers and children of the school and the family in providing this stone 'for one whose loss they so deeply deplore'.

Also from the *Princess Alice* disaster is Sarah Ann Forsdike and three children aged fifteen, twelve and eleven. Another found grave is that of William Alfred Fisher.

Three policemen from the Leman Street station lie in one grave, though they died over a period of six years. PC Richard Barber died in 1884 chasing a suspect across the roof of a railway goods yard. He fell through a skylight and, though rushed to hospital, died shortly after arrival. PC William Pasher drowned while on holiday at Margate. He went to the aid of a swimmer calling for help but both died in the rough sea. PC Ernest Thompson was killed on November 30, 1900, in a disturbance in Union Street, when he was stabbed in the neck with a penknife. He was dead on arrival at the London Hospital.

The river was again the scene of disaster when two related watermen were killed following impact with the Woolwich steam packet *Plover* in 1863. They were Henry Mead (thirty-one) and James Mead (twenty-two). Finally, of many accidental deaths, Tower Hamlets records Peter Yorke, aged fourteen, who fell from a masthead in the West India Dock and drowned.

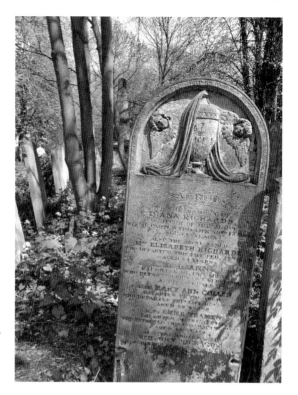

Tower Hamlets' dedication to wildlife conservation is greatest among the London Seven, particularly in the many glades created by wartime damage. Flowers and trees compliment this fine gravestone from the 1840s.

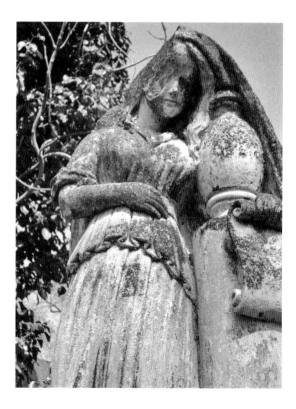

Probably caused by freak bomb damage, the grieving maiden became more poignant still.

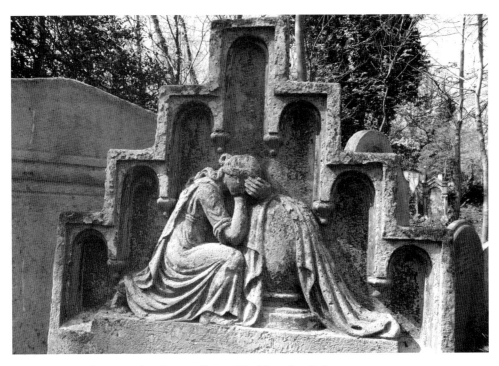

Fine carving and a stepped enclosure distinguish this melancholy group.

Sentiments expressed with weeping willow boughs over classical tomb carvings are a feature of early headstones at Tower Hamlets, here accompanied by a weeping woman.

In this example, note the undercutting of the leaves and the tomb in perspective.

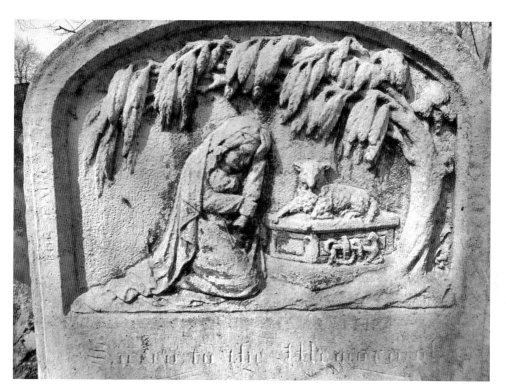

Here the grieving woman is joined by a faithful dog (or possibly Christ as a lamb).

Tree and tomb alone.

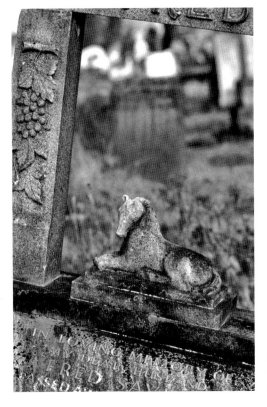

Not as dramatic as monumental horses elsewhere in the London Seven, this little statue clearly meant a lot to the family.

CONTROVERSY AND CRITICISM

Burial in commercial cemeteries was seen by some as an unfortunate dilution of traditional values. Extravagant monuments honoured the dead, but where were the overt Christian symbols such as crosses? This was certainly true in the early years of the Seven when reproductions from antiquity were the fashionable permanent record.

Some radical Dissenters and Roman Catholics had common ground in deriding the neoclassical and mock-Egyptian architecture chosen by certain cemetery companies for their grand entrances and chapels, which was deemed to be pagan.

A convert to Catholicism, Augustus Welby Pugin, was a key figure of the nineteenth-century Gothic revival. An architect, designer and writer, one of his major works was the decorative detail to the Houses of Parliament, inside and out. He was involved at the design stage of at least one cemetery, while being critical of others.

In *An Apology for the Revival of Christian Architecture in England,* 1843, Pugin attacks the commercial venality of cemetery ventures, and includes a veiled lampoon targeting, it seems, Abney Park:

'...to prevent any mistake, some such words as "New Economical Compressed Grave Cemetery Company" are inscribed in Grecian capitals along the frieze, interspersed with hawk-headed divinities and surmounted by a huge representation of Osiris bearing a gas lamp.'

Detail from an Abney Park lodge. Egyptian-revival was a popular style at the time, but mocked by some as pagan and inappropriate.

VICTORIAN PHILANTHROPY AND DEDICATION

Great wealth and aching poverty were close neighbours in nineteenth-century London, though the emerging middle classes would bridge the gap to some extent. In death they would find themselves even closer in the cemeteries. For the great and the good it was possible to ensure posthumous fame through the carved epitaph, noting achievements. Before the advent of the Welfare State, charity and philanthropy were part of the expected order of society.

Thomas William Wing (*d.* 1899), city merchant, had his generous intentions carved deep into a massive granite block at the highest point of Nunhead cemetery. It records: 'He left a name to be blessed by generations of blind persons for whose benefit he bequeathed in trust to the Clothworkers Company of London the sum of £70,000 in Government 2½% Annuities for an annual pension of £20 each, without condition as to sex, age, or place of birth.'

At the other extreme is the 'widow's mite', exemplified by **Clara Grant** at Tower Hamlets (*d.* 1949), whose philanthropy did not wait until the publication of a Will. She was a local school headmistress moved by the poverty of the area to set up the Fern Street Settlement. Known as the Farthing Bundle Lady, she would provide little children with a bundle of toys or clothes for a farthing (the smallest coin).

Some philanthropy amounted to social pioneering. **Sir James Phillips Kay-Shuttleworth** MD (*d.* 1877), buried at Brompton, financed the first teacher training college (in Battersea, south London), which took workhouse children as students. He devised a national system of education and inspection.

One of Norwood's beautiful terracotta mausolea commemorates **Sir Henry Tate** (*d.* 1899), who became the biggest name in sugar trading. He was a Unitarian and supported many charities in Liverpool and London. His gift of a major art collection to the nation founded the Tate Gallery, and he also established libraries in Lambeth, near his London home.

Dr Thomas Barnardo (*d.* 1905), a child welfare pioneer, buried three of his own children in an unmarked grave at Tower Hamlets cemetery. He came from Dublin to

London, destined for the mission field and needing medical training. Child destitution in Stepney so appalled the young doctor that its relief became his life's work; he is buried elsewhere.

Atkinson Morley (*d.* 1858), buried at Highgate, was a hotel proprietor who left £100,000 with which the Atkinson Morley Memorial hospital was built. **Charles Seale-Hayne PC** (*d.* 1903), Paymaster General under Gladstone, bequeathed his fortune to found the Agricultural College bearing his name in Devon (Kensal Green).

The banner of Christian service must be carried by **William and Catherine Booth** who took London by storm after the founding of the Salvation Army in 1865. Women members had equal status. The 'Army' worked boldly on the streets to fight abuse and poverty. Well-maintained shield memorials commemorate two generations of Booths at Abney Park.

Dwarkanauth Tagore (*d.* 1846) was an Indian businessman and philanthropist who used his wealth to develop commerce between India and Great Britain. He knew Dickens and Thackeray, and was grandfather of the poet Rabindranath Tagore (Kensal Green).

Louisa Twining (*d.* 1912) worked to improve the treatment of the poor and destitute, cooperating with Florence Nightingale to send nurses into the homes of the poor. She was from the Twining tea dynasty (Kensal Green).

EUREKA!

The age of the great cemeteries was also one of bold advances in the sciences and in engineering. Many inventors were buried with honours, and sometimes the charlatan too achieved posthumous fame.

Percy Pilcher (*d.* 1899) patented the world's first practical powered aeroplane in 1896. This was seven years before the Wright brothers' flight. He built the plane but died during testing. **Sir Francis Pettit Smith** (*d.* 1874) invented the screw propeller, used on the first successful Royal Navy steamer, HMS *Archimedes*.

Dr John Snow (*d.* 1858) discovered the causes of cholera, leading to the control of the disease that had been filling London's burial places. He was also a pioneering anaesthetist, administering chloroform to Queen Victoria in childbirth. **William Banting** (*d.* 1878) is credited with inventing the 'science' of dieting, and publishing his ideas. Perversely, at barely 5ft, he weighed 14 stone. He was funeral director to the royal family, also managing the funeral of the Duke of Wellington. They are both buried at Brompton cemetery.

Frederick Winsor (*d.* 1830) was the originator of public gas lighting, first installed in Pall Mall in 1808 and later in Paris (where he is buried). His memorial at Kensal Green is capped by a flame and carries a quotation from the Old Testament: 'At evening time it shall be light.'

John St John Long (*d.* 1834) was a quack doctor who died of consumption after refusing to take his own remedy. After the death of a patient he was found guilty of manslaughter but escaped with a fine. Despite all this he has an extravagant memorial.

Food technology, then and now, was a route to wealth. **John Lawson Johnston** (*d.* 1900) was an enterprising Edinburgh butcher who won a French military contract. His first invention was 'Johnston's Fluid Beef' and the next step was a thicker product, marketed as 'Bovril'. He died on his yacht at Cannes. Known as 'Mr Cube', **Sir Henry Tate** (*d.* 1899) was a Liverpool grocer who first packaged sugar in handy cubes, and became dominant in the sugar industry. Like Johnston he later built a mansion in south London. Both were buried in fine mausolea at Norwood.

Three generations of the entrepreneurial Donkin family are buried at Nunhead. The patriarch, **Bryan Donkin** FRS (*d.* 1855) invented the first practical steel nib to replace the quill. His great contribution to food technology was devising an air-tight metal container. He went on to build a large food canning factory in south-east London, and was a director of the Thames Tunnel Company that appointed Marc Brunel as engineer.

There are brilliant medical men buried at Highgate. **Sir Thomas Brunton** (d. 1916) recognised the connection between angina and high blood pressure. Countless lives were saved in the First World War by the typhoid vaccine developed by an army doctor, **Lt-Gen. Sir William Leishman,** while **Frederick Pavey** (*d.* 1911) revealed the nature of diabetes, and devised a test for blood sugar levels.

Taking the crown, perhaps, for fame if not fortune is **Michael Faraday** (*d.* 1867), who discovered electro-magnetic induction and constructed the first electric motor, transformer and dynamo. He is buried without pomp at Highgate. But one of the best ideas of the era came from the inventive mind of **Bennet Woodcroft** FRS (*d.* 1879), who founded the Patent Office to protect his own intellectual property! Among Woodcroft's projects was the opening of the vault and coffin of the 1st Marquis of Worcester, devoted supporter of Charles I. The Marquis had invented an early 'water lifting machine', and it was said that a model of the machine went with him to his grave. Woodcroft's search proved fruitless.

John St John Long, the doctor who would not take his own cure, is a shadowy presence under his expensive memorial dome. Note the medical symbols.

PALACE OF VARIETIES

Music Hall, theatre and circus occupied a place in the hearts of late Victorian and Edwardian Londoners only matched by television today. Star performers might play two or three venues in one night, if the cab got through the traffic on time. Rewards could be considerable, retirement comfortable and funerals lavish – the opposite being equally true.

The great cemeteries hold echoes of many colourful performers who 'topped the bill' in their day.

Never quite out of the limelight even today, **George Grossmith** is best known for the *Diary of a Nobody*, written with his brother Weedon. Primarily he was an entertainer, a comedian and singer, creator of leading roles in Gilbert and Sullivan operettas. He died in 1912 and is buried at Kensal Green. Harry Clifton (*d.* 1872) immortalised a west London location in his music hall song, 'Pretty Polly Perkins of Paddington Green.'

Still in Kensal Green, the elaborate mausoleum created by **Andrew Ducrow** (*d.* 1842), initially for his wife, was called 'ponderous coxcombry', and bears the inscription 'This tomb is erected by genius for the reception of its own remains'. Touching tributes in stone – a lady's hat and gloves on a fallen column – may still be seen. He was proprietor of Astley's Amphitheatre (a permanent circus in central London) where his feats of horsemanship were acclaimed. A later proprietor of Astley's, **William Batty** (*d.* 1863) (also in Kensal Green) staged chariot races in Hyde Park during the 1851 Great Exhibition. His grave is a modest one, however.

George Wombwell (*d.* 1850) was proprietor of the country's largest travelling menagerie in the mid-nineteenth century, while the younger **Frank Bostock** (*d.* 1912) was another noted 'menagerist'. Both showmen lie under remarkably similar monuments (Wombwell at Highgate, Bostock at Abney Park). These are substantial chest tombs on which life-size stone lions rest in apparent sleep. A handbill promoting the Royal Surrey Zoological Gardens in Walworth, south London (later destroyed by fire) has Wombwell's gorillas topping the bill, Bostock's name appearing in much smaller typeface.

Paul Cinquevalli (a stage name) was the greatest juggler of his time. His tricks included the 'human billiard table', running balls over his body into pockets. He was capable of juggling balls while carrying a man sitting on a chair, in his mouth. Cinquevalli, whose real name was Braun, performed in the first Royal Variety Performance of 1912, and died in 1918; he was the subject of anti-German sentiment in his later years.

Synonymous with his famous song, 'Champagne Charlie', the music hall artiste **George Leybourne** (*d.* 1884), shares his Abney Park resting place with son-in-law, **Albert Chevalier**, another much admired singer/entertainer of the next generation. He wrote the equally popular 'Knocked 'em in the Old Kent Road'.

Alfred Glanville Vance (another stage name) was a contemporary and friendly rival of George Leybourne. A dancer and comic singer with a huge repertoire, he was one of the first to begin his act with a signature tune. He died on stage at the Sun Music Hall, Knightsbridge, on Boxing Day 1888. Over 1,000 admirers attended his Nunhead funeral.

A story of rags to riches in the more serious theatre is represented by **Lilian Adelaide Neilson** (*d.* 1880). She was a Yorkshire mill girl with good looks and talent who became a serious actress of international repute, attracting the eye of the composer Berlioz in Paris. Her grave is at Brompton.

Twentieth-century entertainers are prominent at Highgate. **Sheila Gish** (*d.* 2005) was a noted film and stage actress, acclaimed in the lead role of Tennessee Williams' play *A Streetcar Named Desire*. A much-loved cabaret pianist and singer, **Leslie Hutchinson (Hutch)**, an early television entertainer, died in 1969. **Max Wall**, who died in 1990, made a remarkable transition in later life from comedian to straight actor, notably in Samuel Becket's plays.

Books relating to Music Hall personalities at Norwood and Nunhead cemeteries have been published by the respective Friends groups.

BARE-KNUCKLE SUPERSTARS

Bare-knuckle boxing was a semi-legitimate and highly popular activity in the Victorian era, ending when the Queensberry rules were introduced in 1867. It was supported across the social classes with large sums of money gambled on results. The leading exponents were lionised and often well rewarded, as the name prize-fighter implies. Some were able to better themselves, having survived to enjoy retirement. By all accounts their funerals were as colourful as the lives they led.

Several such boxing celebrities were buried in Brompton, Highgate, Nunhead and Norwood cemeteries.

John 'Gentleman' Jackson (*d.* 1845) was a prize-fighter who established a self-defence school in London's exclusive Bond Street. He was also able to teach his brother wood-engraving, enabling him to become a successful illustrator. His classical monument at Brompton (Grade II) is surmounted by a benign lion, and bears his Romanised bust draped with laurel. It was paid for by public subscription.

Thomas Sayers (*d.* 1865), British champion, fought a long and punishing world-championship bout against the American champion John Heenan, when a draw was declared after more than four hours fighting, and police intervened on account of crowd behaviour. After this Sayers and Heenan teamed up as touring entertainers. He was to be seen about town with his huge dog – a mastiff called Lion. Tom lies at Highgate where, it is said, 10,000 people attended his funeral. Prominent on the occasion was Lion, who led the cortege in his own carriage. Subsequently the dog drew its own crowd when it was sold to a new owner at auction. It now lies in effigy above the grave.

James Ward (*d.* 1884) was known as **'The Black Diamond'** because when he started fighting his skin was blackened from working on coal barges in the London docks. He gave this up for bare-knuckle boxing and was twice proclaimed British champion. During a long retirement as an inn- and hotel-keeper he developed talents in painting and musicianship. He painted the Sayers versus Heenan fight (see above) on a large scale, packing the scene with portraits of leading personalities. Ward died in his eighties near Nunhead and is buried there.

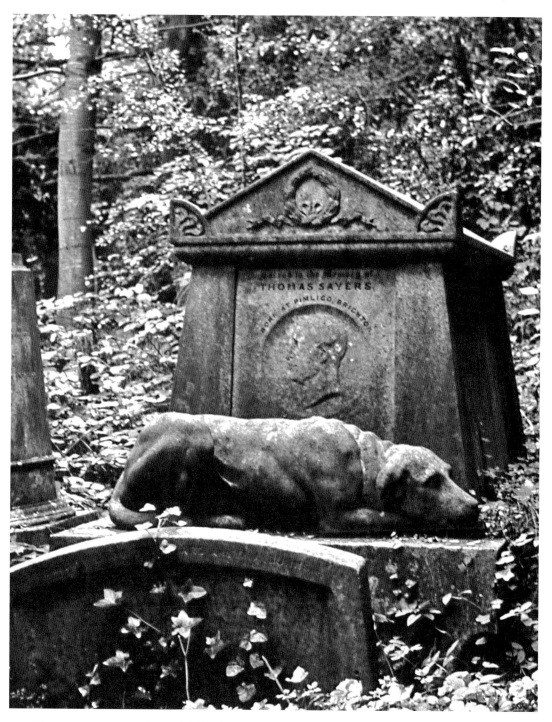

Tom Sayers, mourned by his faithful dog.

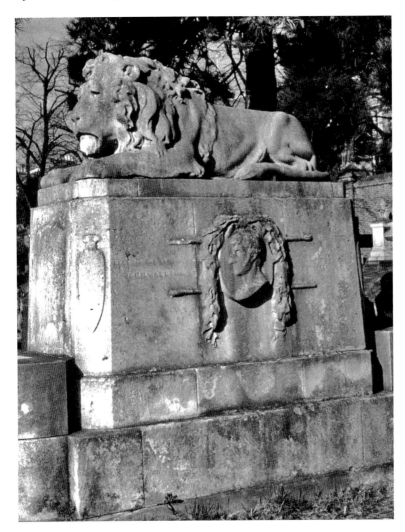

John Jackson is represented by a lion and a Roman-style cameo.

Another strong dock worker who turned to prize fighting was **Thomas King** (1835-88), the last British champion. He too fought and, this time, defeated the American champion Heenan (see above), taking the world title as well. King became a successful bookmaker, and is buried at Norwood.

We must return to Brompton to find a record of a prize-fighter whose end was probably more typical. **Alexander Reid** (1802-76) was known as the 'Chelsea Snob', credited with inventing the uppercut to put an end to the practice of head butting. Sadly he became punch-drunk and ended his days in a workhouse. There is no headstone.

Also at Nunhead we find **Tom Belcher** (*d.* 1854) who was one of a family of fighters. He won a prize of 100 guineas for beating a noted Irish boxer on his own turf. He became a pub landlord, and was a page at the coronation of George IV.

Vivid accounts of other Victorian prize-fighters can be found in *Sportsmen* by Bob Flanagan, published by the Friends of West Norwood Cemetery.

THE TALL TALE OF LONG JENKINS

Re-interment is the perfectly legitimate removal of buried remains from one location to another, and it was not uncommon for one or another of the Seven to be a recipient in this way. An early example is found at Nunhead which involved the elimination of an ancient city church and churchyard together with a coffin too large to be buried conventionally.

The small city parish of St Christopher-le-Stocks included the part of Threadneedle Street occupied by the Bank of England. The church, dating from the thirteenth century, was rebuilt soon after the Great Fire of 1666 by Christopher Wren, only to be demolished in 1781 to enable the rebuilding of the Bank under another eminent architect, John Soane.

The churchyard containing some 2,700 bodies became a garden within the Bank area. Mammon, in the guise of the Bank of England, having pushed aside a church, thought little of devouring the former churchyard also. This it did through further building in the mid-1860s, when the burial vaults were cleared and twenty-three large cases of human remains were re-interred in Nunhead's eastern catacomb.

Twentieth-century reconstruction work at the Bank resulted in all the other churchyard burials being moved in stages to Nunhead vaults in 1933. There were seventy-four cases of human bones and twelve lead coffins.

At this point a named deceased enters the story. William Daniel Jenkins was an employee of the Bank of England, known as Long Jenkins on account of his great height. He died in 1798 at the early age of thirty-one and was buried in the walled garden of the Bank (the former churchyard).

During the exhumations of 1933, a massive lead coffin was found at a depth of 8 ft (6 ft being a standard burial depth). With a length of 7 ft, and weighing 3 hundredweights, it was too large for a Nunhead vault and was deposited in the main catacomb.

The balance of probability links the coffin with the body of William Daniel Jenkins. If so, why was he buried in the garden (no longer a burial place), and at a depth greater than normal? This was the period of great demand by anatomy schools for interesting

cadavers, often supplied through the criminal trade of grave robbing (see Snatching and Burking on next page). A 7 ft giant would be of great value – and worth exhibiting as a curiosity.

Protection of the body was therefore the probable reason for the special concession of burial in the Bank's walled garden, and at extra depth to increase security. There is no certainty that the body has remained undisturbed in the Nunhead catacomb, which was sealed up in the 1970s.

For a complete account of Nunhead's abandoned catacombs see *The Victorian Catacombs at Nunhead* by Ron Woollacott (published by the Friends group).

SNATCHING AND BURKING

Medical science was making great headway in the early decades of the nineteenth century. The teaching hospitals of London and Edinburgh, in particular, boasted anatomy schools that needed a steady supply of fresh human cadavers for dissection by students.

Such supply was a legally 'grey area' requiring contacts in prisons and other institutions, and discrete cash payments. Working on the basis of ask-no-questions, some anatomy schools also dealt with grave-robbers or body-snatchers – men who haunted churchyards and private burial grounds in order to dig up recent interments. Members of this low-life fraternity were also known as resurrection-men.

Financial greed on the one hand, and demand for corpses on the other led to more serious criminality – the stalking of dying paupers, for example, and the hastening of death in some cases, so that corpses could be sold pre-burial.

From here it was but a small step to stalk and murder vagrants and others unlikely to be missed. The ever more crowded cities were rich in such pickings, with children and prostitutes being as freely available as the elderly and infirm.

This trade was exposed to the glare of publicity through the Press in the notorious Edinburgh case of Burke and Hare in 1828 – resulting in death sentences.

In consequence, those resurrection-men, who were prepared to murder for financial gain, acquired the tag burkers, their activity being burking. Some three years after the Edinburgh trial, the spotlight switched to London with a sensational case involving East End 'resurrectionists' turned burkers.

Parliament soon passed the Anatomy Act (1832) permitting unclaimed bodies of paupers to be made available for medical dissection. This did not immediately halt the criminal trade, while the prospect of jewellery on corpses also attracted thieves. So when the great new London cemeteries were being planned towards the end of the decade, they were provided with high walls, stout gates and tenanted lodges. Thus prospective customers were reassured that their dear departed would indeed rest in peace.

For a vivid account of this subject see *The Italian Boy: Murder and Grave-Robbing in 1830s London* by Sara Wise, 2004.

SYMBOLS OF MORTALITY

Anchor and/or rock: holding fast to the rock of Christian faith, and sometimes recording a seafaring person.

Angel: winged messenger; comforter, sometimes seen bearing the deceased to heaven.

Broken column: signifies life cut short, especially the head of a family.

Celtic cross: from ancient Celtic Christianity, the central circle symbolising eternity.

Inverted torch: life extinguished; a powerful image when such torches were still used in London.

Cherubs: adopted in Christian art from pagan origins; symbols of hope, also innocence; often found with flower garlands (a prominent motif on Christopher Wren's St Paul's Cathedral).

Clasped hands: recalling a loving bond; parting and/or reunion in the next life.

Dove: a symbol of the Holy Spirit (a bird ascending is the Holy Spirit rising up).

Draped urn: the urn is copied from antiquity, possibly a vessel for the soul (as well as for the ashes of the dead), the drapery being an additional sign of mourning; a very popular symbol in the Seven cemeteries.

Drooping foliage: mourning (especially the weeping willow).

Hourglass: the passing of life's allotted time; a *memento mori*, as is a carved skull.

IHS: Greek abbreviation for Jesus Christ, Man and Saviour.

Lily: a Christian symbol of purity and peace.

Obelisk: from Egyptian antiquity, associated with the sun god, and eternity.

Palm frond: Christian triumph and resurrection.

Pyramid: from antiquity, symbolising eternity (when three-dimensional), otherwise probably Masonic.

Serpent/snake: from Egyptian antiquity, health and life; as a circle, eternity.

Set-square and compasses: Masonic symbols.

Wreath: winning an eternal prize.

Clasped hands. (*Photo S. Berryman*)

Snake circle.

Broken column.

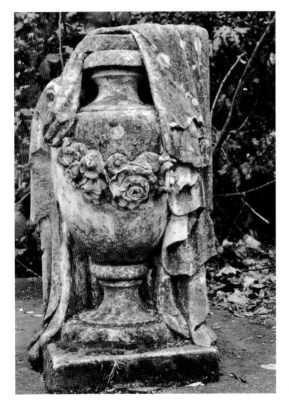

Draped urn. (*Photo S. Berryman*)

NATURE CONSERVATION –
WOOD WORK

Nature conservation in the Magnificent Seven has become increasingly important since the main period of 'rescue' in the 1970s and 1980s. Owners (local councils and registered charities) together with Friends groups recognise their responsibilities, and hundreds of paid and volunteered hours per year are directed towards this agreeable task.

Key to the management issues involved is balance, between enriching the sites for wildlife generally and for scenic appeal, while maintaining good access for visitors, especially those tending family graves. And this must be done on tight budgets, with minimal intervention in terms of power tools or chemical weed control.

Conflicting interests arise. A large blackberry clump may obscure a number of graves and send spiny growths out into paths. But it is a haven to birds like the wren, while providing nutritious fruit for wildlife and humans. Ivy, originally planted for its sombre effect, is often prolific in cemetery trees and the extra weight may cause sick or shallow rooted trees to topple easily. But ivy is winter fruiting (like holly) and is an important food source for birds, so conservation policy usually favours the birds and most ivy is left in place.

Removal of overcrowded young ash and sycamore trees (the latter often diseased) is generally part of conservation policy. This may have the benefit of opening up a piece of ground to sun and air, resulting in a mini-meadow environment. Other tasks include ensuring paths are passable, and perhaps removing seedling trees from graves fronting paths. Increasingly, long grass is being encouraged in open areas and this, with accompanying wild flowers, needs traditional late summer mowing and raking away.

Generally, our cemeteries are becoming good butterfly habitats, at a time when many butterfly types are increasingly scarce.

Small mammals and insects are encouraged by stacking cut branches and scrub to make 'habitat piles' in which they may breed. Fungi too, flourish in old timber on the ground. Such activities form part of management policies and plans for cemeteries, with variations to match locations.

Ponds attract bats that hunt emerging insects on the wing, as well as providing habitats for our increasingly rare amphibians. Marginal water plants bring another dimension. Tower

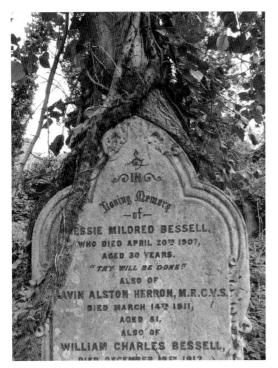

In
Loving Memory
—of—
ESSIE MILDRED BESSELL,
WHO DIED APRIL 20TH 1907,
AGED 30 YEARS.
"THY WILL BE DONE!!"
ALSO OF
AVIN ALSTON HERRON, M.R.C.V.S.
DIED MARCH 14TH 1911,
AGED 51.
ALSO OF
WILLIAM CHARLES BESSELL,

Ivy embraces a headstone as it clambers into a tree; however, ivy is appreciated by birds and insects.

Here young sycamore trees damaging stone curbs have been cut back and may be treated to deter re-growth.

A variation on the 'habitat pile' of woodland trimmings left for wildlife; here the material has been dug in vertically to attract insects such as beetles, and also fungi.

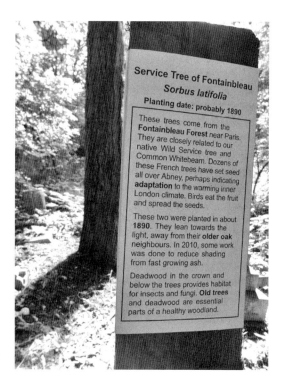

Service Tree of Fontainbleau
Sorbus latifolia
Planting date: probably 1890

These trees come from the **Fontainbleau Forest** near Paris. They are closely related to our native Wild Service tree and Common Whitebeam. Dozens of these French trees have set seed all over Abney, perhaps indicating **adaptation** to the warming inner London climate. Birds eat the fruit and spread the seeds.

These two were planted in about **1890**. They lean towards the light, away from their **older oak** neighbours. In 2010, some work was done to reduce shading from fast growing ash.

Deadwood in the crown and below the trees provides habitat for insects and fungi. **Old trees** and deadwood are essential parts of a healthy woodland.

Better awareness of the landscape comes from information such as this tree-trail at Abney Park.

At Nunhead an area has been reserved for 'woodland burials', marked only by small trees. This popular site will become a copse of mixed species.

Hamlets' cemetery park has ponds associated with its education centre, and Nunhead has a seasonal pond in wet clay on high ground where hidden springs seep water.

Visitors comment on the wealth of spring bulbs, primroses, bluebells and later flowers in the cemeteries. Many originated as tokens planted on graves, which then gradually spread. Some were distributed as seed by wildlife, while recent additions result from planned diversity schemes.

For better or for worse, most of the Seven are well wooded, and these 'secondary' woodlands (they are relatively modern, not ancient) are statutory conservation areas or nature reserves. Without them, London's green lungs would be fewer, a loss of some 250 acres of purifying greenery.

But there has been a price to pay through damage to graves and monuments. Roots can cause tilting of masonry and hasten the collapse of vaults. Fast growing seedlings, such as ash and sycamore, nestling between stonework will push it asunder in time. Finely carved tops of monuments can suffer damage from swaying branches and falling timber. All this and more has been happening for sixty years at least, leading to the effect of 'romantic ruin' that some visitors find shocking, though for many it is the Gothic frisson that is the unique quality of the great cemetery experience.

Pleasant times can be had taking part in voluntary work in the great cemeteries amid beauty at all seasons. Find out more from the websites, or go along on a Sunday when working groups or guided tours often gather.

RECORDING THE PAST

Genealogy is assured of a good future. Never has the tracing of ancestors been more enthusiastically taken up than in the present century, thanks largely to promotion of the subject in the media, and available computer software to get one started on a quest.

However, professional and volunteer staff at the Magnificent Seven cemeteries have always been busy with requests for help in finding family graves, perhaps back to great grandparents or those lost in a war. As well as family interest in the lost graves of relatives, there exist clubs whose members seek to piece together the buried past of a community or a geographical area.

Sadly, in each of the great cemeteries there are thousands of graves where it is no longer easy – sometimes impossible – to read names and dates on stones due to weathering, collapse, vandalism or inaccessibility.

The cemeteries were mapped on numbered square grid plans, and records of burials within a particular square may still be available in cemetery archives. Burials were also recorded chronologically, which would confirm the place, but there may not be a cross reference to a grid square. These old record books have not all survived the ravages or war, damp, fire and vandalism, so the quest for information may stall at this point.

Most helpful is to have a memorial card dating from the time of burial that has been passed down through the family, and that hopefully bears the grid square number. Then with a gridded map supplied by the cemetery office, the seeker must try to locate the square and search within it. In practice, cemetery staff or volunteers may be able to help with the location of a square, and it may happen that the particular area has been recorded recently.

Recording details from graves is a vital task carried out by Friends groups – legibility on stones fading with each passing year – and it is slow, patient work. Volunteers to help with this rewarding activity are welcomed at the great London cemeteries and elsewhere.

Members of the Myatt family visit the grave of Joseph Myatt (*d.* 1855), an innovative horticulturist, at Nunhead.

Tower Hamlets' genealogical research has led to permanent plaques with 'family trees' beside stones no longer legible.

CEMETERIES NEED FRIENDS

The plight of the great London cemeteries in the 1970s and 1980s led to the formation of Friends groups to promote local awareness of what was under threat from neglect, vandalism, and possible change of use. Interest centred variously on heritage issues, and on aspects of wildlife in the extensive woodlands that had developed among the burials in the twentieth century. Establishing good relations with owners – often local councils – was a priority, leading to forms of shared operation.

A natural development was an interest in each other's activities and willingness to share early successes or frustrations. In 1986, these contacts were formalised with the creation of the National Federation of Cemetery Friends, launched by Friends groups within the London Seven, but seen at the outset as a nation-wide resource. Membership rose steadily, with annual meetings alternating between London and important provincial cemeteries that had needed to establish Friends groups and sought Federation support.

The Federation handbook, *Saving Cemeteries* (revised 2009), states that the objectives of the Federation are to promote the understanding and appreciation of cemeteries, and actively encourage their preservation and conservation, as well as providing mutual help and support.

Meanwhile within the expanding European Union there was growing awareness of national histories and cultural heritage half-forgotten in city cemeteries. This time the common interest was at the level of government, rather than from grass-roots as in the UK, and led to the formation of the Association of Significant Cemeteries in Europe in 2001, which recognises a number of sites in the UK, introducing them to a new European audience, while presenting through published material in English the extraordinary wealth of cemeteries across Europe.

www.cemeteryfriends.org.uk
www.significantcemeteries.net

PÈRE LACHAISE –
THE FRENCH EXEMPLAR

Dating from 1804 and extending to 105 acres in the eastern 20th *arrondissement* of Paris, Père Lachaise cemetery is both older and larger than any of the London Seven. It was recognised as the model for the English cemetery movement some decades later, being a newly-developed edge-of-town landscaped site, rather than a burial place beside an ancient church.

In landscape terms, Père Lachaise offered features that chimed with the aesthetic of the London planners of the late 1830s. The site is hilly, rising sharply from an avenue that also carries a metro line. Though British critics at the time considered the lines of graves too geometric, leaving no space for natural plantings, in reality paths twist and turn up and down the hillside, and many trees and shrubs have been encouraged to grow, especially at higher levels.

With its major paths suitable for vehicles, the London cemetery that most resembles Père Lachaise is Norwood, though its steepness evokes Highgate.

The curious name derives from an eminent Jesuit friar – King Louis XIV's confessor – who retired to a hospice on that site. The Jesuits lost favour under Louis XV and the Mont-Louis site passed to other hands. However, under Napoleon I the property was re-acquisitioned for the State and the City, and developed as the Eastern Cemetery, later renamed in honour of the good friar.

Today the cemetery is well-maintained and staffed, important monuments attract restoration, and the host of world celebrities buried there ensures a constant flow of visitors.

A group gathers for the monthly tour at Nunhead.

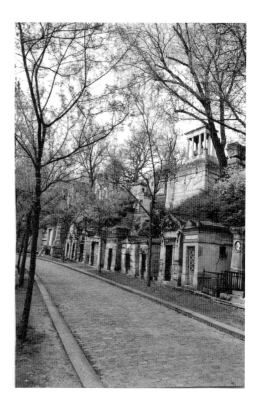

A well-maintained precursor of the London
Seven, Père Lachaise cemetery in Paris.
Crowded mausolea climb the hillside among
spaced trees.

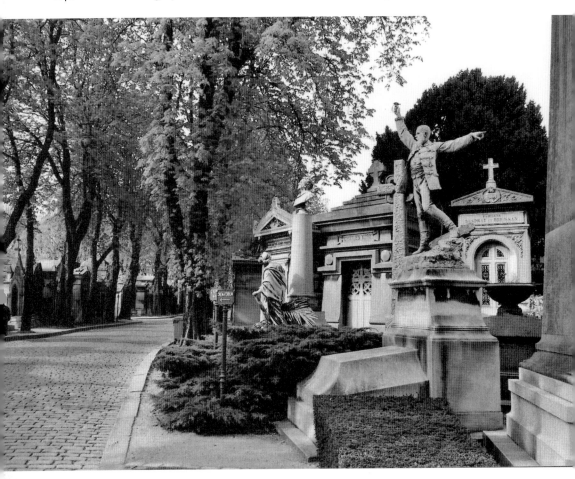

There are also flamboyant memorials on the main avenues.

THROUGH THE SEASONS

Spring blossom in Abney Park.

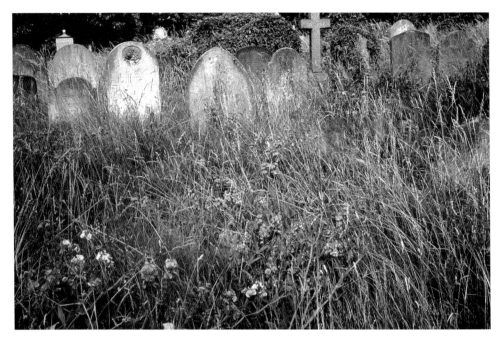

Summer flowers in Brompton.

Autumn shadows on high ground at
Nunhead.

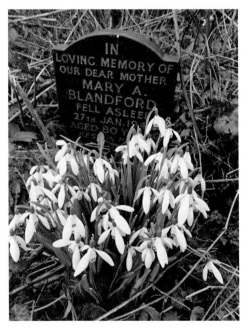

Late winter snowdrops.

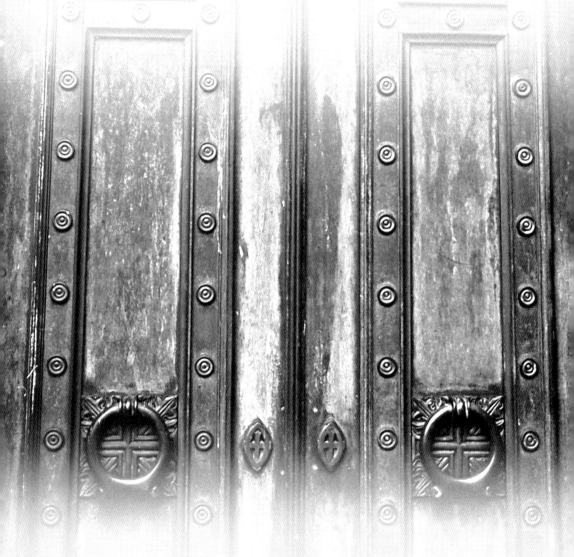

DOORS – SYMBOLS OF CLOSURE

Cast metal doors have been objects of art and authority since Renaissance times; this nineteenth-century example comes from Norwood.

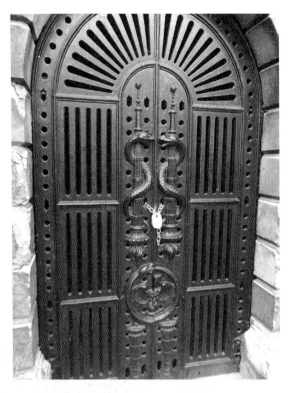

An example from Brompton with powerful symbolism.

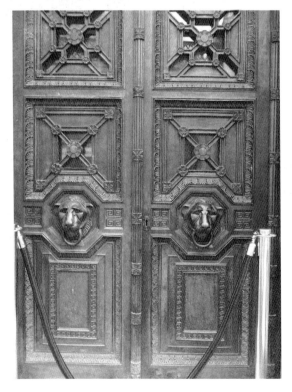

The doors of the Julius Beer mausoleum at Highgate.

MODERN MEMORIALS

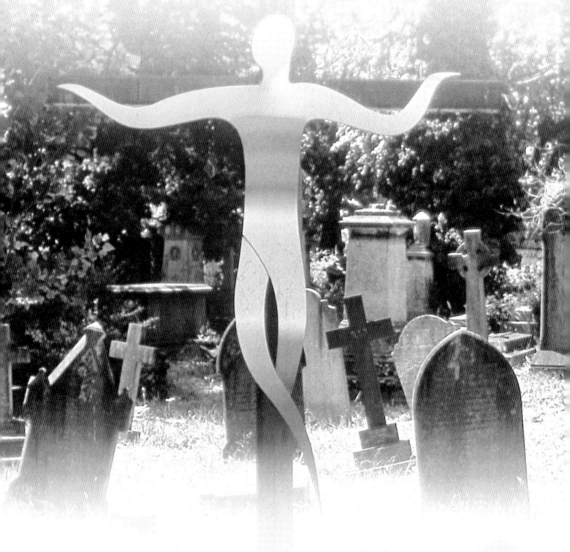

This crucifix stands in Kensal Green.

A version of 'winged victory' contrasts with timeless stone at Kensal Green.

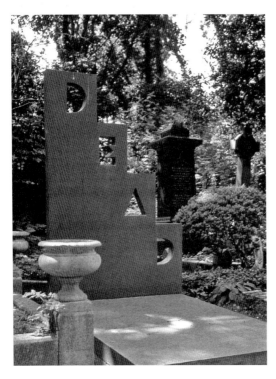

An artist makes a personal comment in Highgate East.

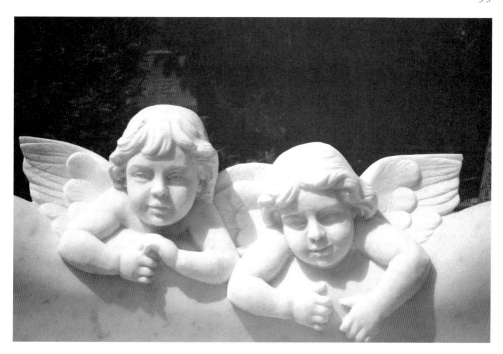

Cheeky cherubs show that master carvers are still at work.

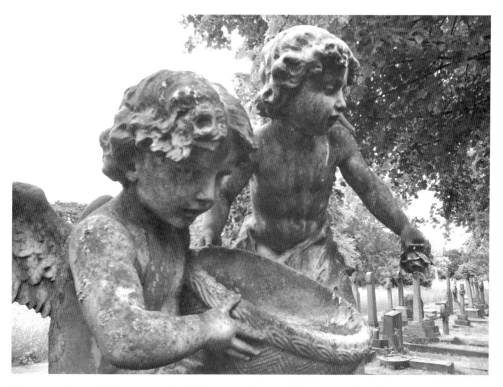

By comparison, this Brompton detail shows early twentieth-century cherubs.

POSTSCRIPT

While the Seven cemeteries continue to enjoy adequate management and public support, their futures seem secure. There are issues, however, some beyond local control, which may impact on the enjoyment of these landscapes.

Implementation of Health and Safety regulations is already evident in cemeteries. Fenced or taped-off monuments are commonly seen, and even large areas of woodland are denied to the public because of the perceived danger from toppled stones, hidden curbs or perhaps tree roots and fallen branches. It may be too much to hope that the 'nanny state' and fear of litigation will diminish in the future – it may well intensify.

So much depends on financial support. If funds are available for monument repairs, pathway maintenance etc., then the perceived risk of accidents recedes. Is it too much to hope that environmental funding at government and local level can be increased in recognition of the benefits of free, safe access to healthy heritage sites such as the Seven? A good sign is that two official London walking routes pass through a northern and a southern cemetery.

Increasing the attractiveness and visitor numbers in the Seven is also a sure way to combat anti-social behaviour, which is prevalent in many urban areas during the daytime – cemeteries providing some privacy and freedom from hassle. The regular presence of paid or volunteer staff willing to act on police advice is a proven deterrent. What must not happen is a knee-jerk reaction to complaints that lead to the severe cutting back of shrubs and young trees. Sadly, this has been the case in other public spaces.

A final issue – a nettle that may have to be grasped – is that of re-use. Burials are now far less numerous than cremations, but demand is steady, especially among some religious or ethnic groups. Re-use of old burial sites, ideally when occupied by only one interment, is not uncommon elsewhere, and it may not be realistic to expect the London Seven cemeteries to be exempted from a popular policy. Great care will be needed, however, to preserve the best of the past with the needs of the future.

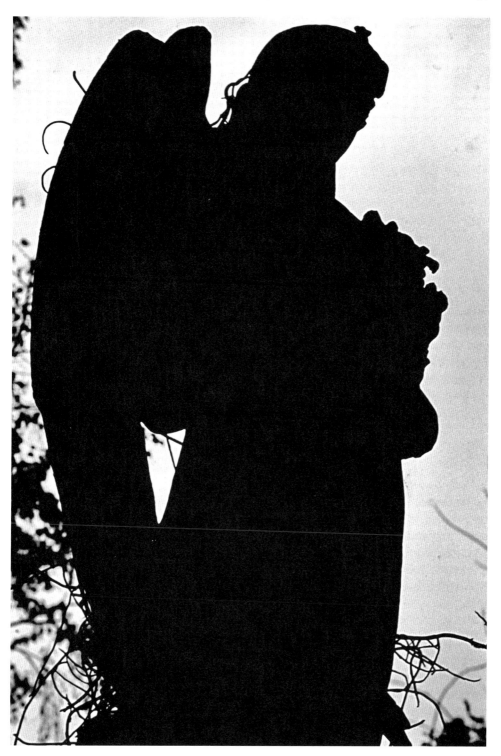

An angel keeps watch.

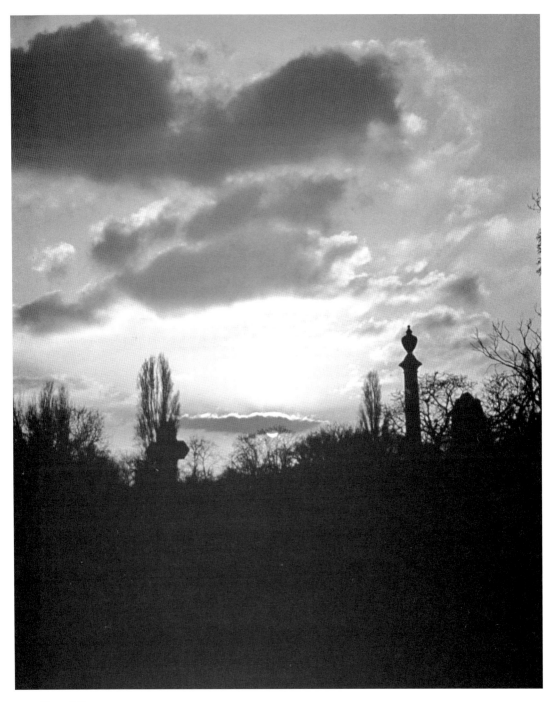

Kensal Green sunset.

FURTHER READING

Arnold, C. *Necropolis: London and Its Dead*, Simon and Schuster, 2007

Beach, D. *London's Cemeteries*, Metro Publications, 2006

Brooks, C. *Mortal Remains: the History and Present State of the Victorian and Edwardian Cemetery*, Wheaton, 1989

Curl, J. S. *Kensal Green Cemetery*, Phillimore, 2001

Curl J. S. *The Victorian Celebration of Death*, Sutton, 2002

Meller, H. and Parsons, B. *London Cemeteries: An Illustrated Guide and Gazetteer*, History Press, 2008

Rutherford, S. *The Victorian Cemetery*, Shire, 2008

Wise, S. *The Italian Boy: Murder and Grave-Robbery in 1830s London*, Jonathan Cape, 2004

The Friends groups have publications devoted to their own cemeteries, obtainable via the websites or from site offices (check opening times).